SISLEY

SISLEY

Richard Shone

Phaidon Press Limited
Regent's Wharf, All Saints Street, London N1 9PA

Phaidon Press Inc.
180 Varick Street, New York, NY 10014

www.phaidon.com

First published 1979
Second edition, revised and enlarged, 1994
Reprinted 1994, 1995, 1998, 2000, 2002, 2003, 2005,
2007, 2011
© 1979, 1994 Phaidon Press Limited

ISBN 978 0 7148 3051 3

A CIP catalogue record for this book is available from the
British Library

Printed in Singapore

The publishers would like to thank all those museum authorities and
private owners who have kindly allowed works in their possession to
be reproduced.

Cover illustrations:
Front: *Near Marly: Snow on the Road to Saint-Germain,* 1874–5
Back: *Sentier de la Mi-côte, Louveciennes,* 1873 (Plate 12)

Sisley

The Chinese painter Kuo Hsi, who worked in the eleventh century, left a treatise on landscape painting in which he wrote of the themes and subjects suitable for a painter: 'There are four seasons, and each season in its turn has a beginning and an end. The morning and the evening, the moods of objects and the colours of things must all be analysed. Moreover, each has its characteristic mood.' He goes through the seasons listing their possible subjects – spring clouds clearing after rain and the last of winter snow; morning walks through summer fields and afternoons of blue sky and cumulus clouds; autumn mists and west winds bringing rain; winter gloom heavy with snow, chilly clouds and snowy paths. He takes pleasure in misty streams, snow at dawn, autumn haze in the evenings. Reading of these we enter Sisley's world, for they were his constant subjects in a career devoted almost entirely to landscape. We must exchange, however, the mountains and cascades of Kuo Hsi's China for the less dramatic topography of the Ile-de-France, of those 'heroic centres of Impressionism' – Louveciennes, Marly, Argenteuil, Bougival; and the expansive flow of the rivers Seine and Loing takes the place of rushing torrents and waterfalls.

The subtlety and quiet variety of the landscape in which Sisley passed most of his working life are embodied in paintings which, while immensely varied in quality, consistently express his deep attachment to that area. He rarely left it (there were three visits to England) and never went south; next to Pissarro he was the least travelled of the original Impressionist group. Early on he seems to have reached a very clear idea of his preferences and limitations, and although new types of subject occur in his work (and others disappear), the essential impulse to explore effects of atmosphere, light and mood remains. He did not have the restless intellect of Pissarro or the grand ambition of Monet, the two painters with whom he has most affinities among the Impressionists. Surveyed as a whole, his work is on a smaller scale than theirs, but he did produce individual paintings which must be among the finest of nineteenth-century landscapes and which made a definite contribution to the Impressionist movement. His perfection of tone, sureness of composition and variety of handling are in perfect accord with a sensibility that was frank, tender and transparently sincere.

There is a painting by Renoir – his first large figure-composition – that shows a group of friends being waited on at table in a country inn (Fig. 1). In the foreground is a young, bearded man, well dressed, a newspaper in front of him, who has his head turned away from the spectator. It is Alfred Sisley, Renoir's close friend and painting companion at this time. Turned away from us, Sisley's attitude might be taken as representative of his shadowy presence among the Impressionists, for he is the least known of them. Monet and Renoir are immensely well documented as people, particularly from eye-

Fig. 1
Pierre-Auguste Renoir
Mother Antony's Inn
1866. Oil on canvas,
195 x 130 cm.
Nationalmuseum,
Stockholm

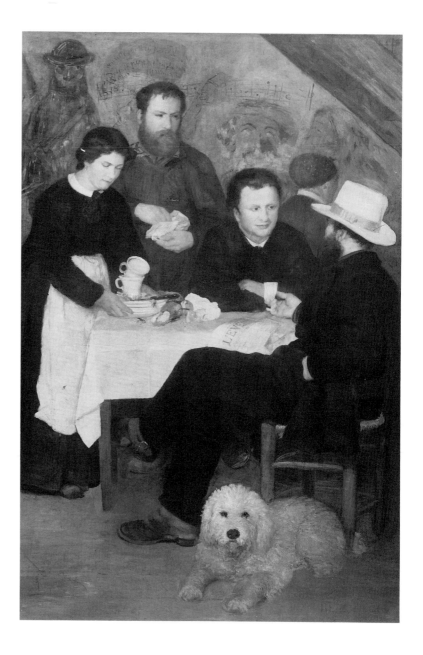

Fig. 2
Photograph of Alfred
Sisley
c.1872-4. Archives
Durand-Ruel, Paris

witness accounts, from letters and photographs and the finds of innumerable researchers. Pissarro was a prolific letter-writer and many fugitive details of his life and working habits have come down to us. But with Sisley we come again and again to a full stop – few revealing letters and documents, two or three photographs (Fig. 2), one statement about his painting, and several years about which we know little beyond his place of residence. A few, often-repeated facts have frequently been found incorrect on recent examination and contemporary descriptions of him are rare. This lack of knowledge is partly explained by his retiring character, which became more so with the years until towards the end of his life he rarely stirred from Moret-sur-Loing, the small country town on the edge of the Forest of Fontainebleau where he died. Since then he has never been an unpopular painter but he has suffered critical neglect, too easily dismissed as a poetic charmer with a nice line in snow scenes and floods.

His father, William Sisley (1799-1879), was a prosperous business-man dealing in textiles, initially based in London's Watling Street behind St Paul's Cathedral, but spending much of his life in Paris. His wife Felicia Sell (who was also his cousin) was the daughter of a

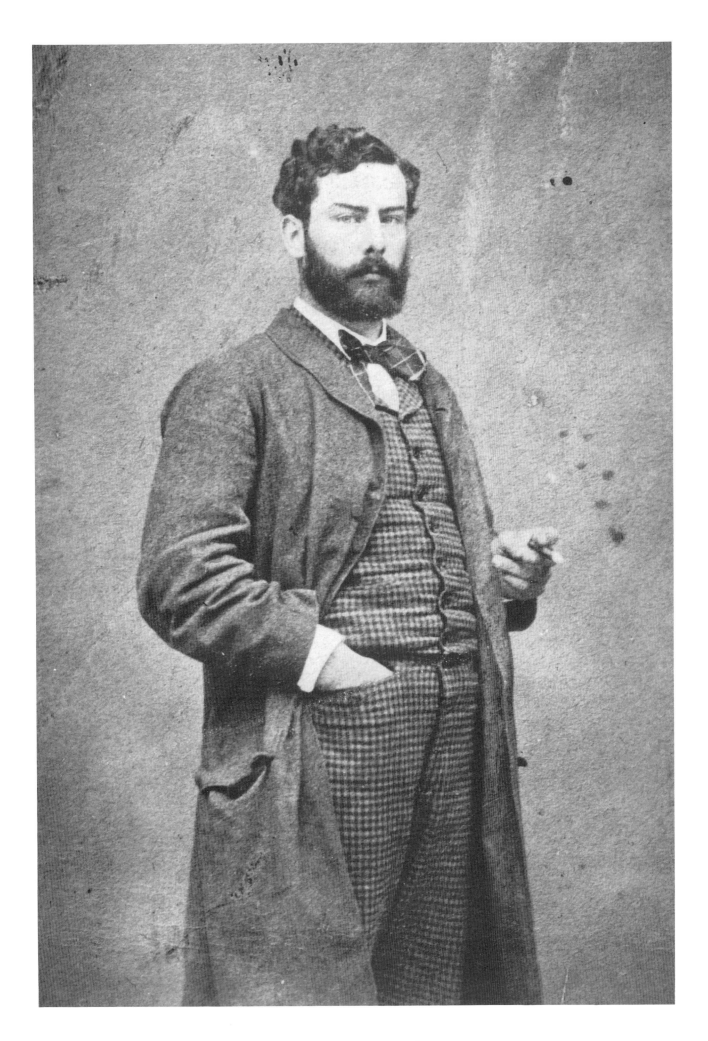

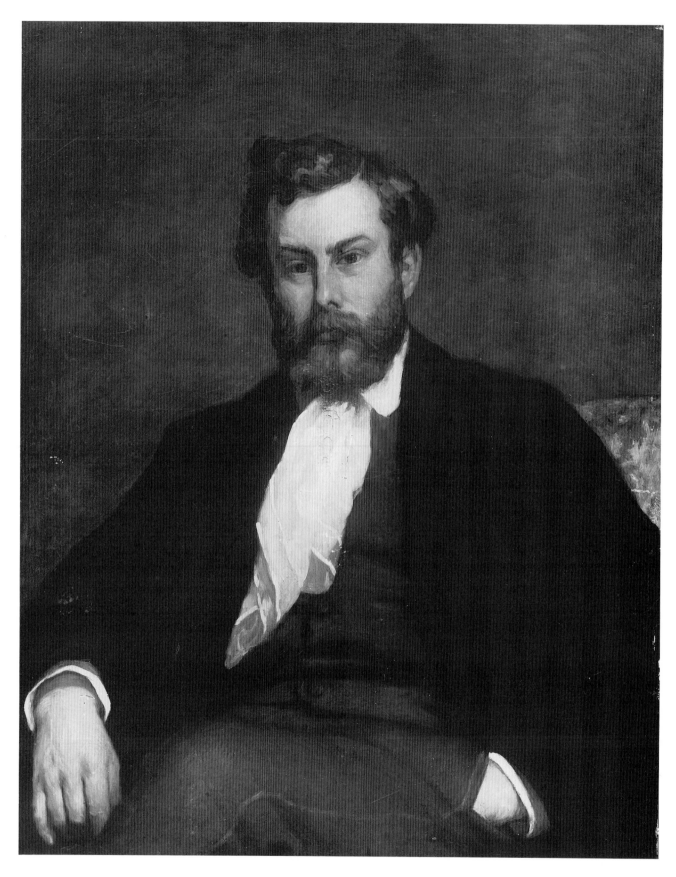

Fig. 3
Pierre-Auguste Renoir
Portrait of Alfred
Sisley
1864. Oil on canvas,
80 x 65 cm. Fondation E.
G. Bührle Collection,
Zurich

saddler from Lydd in Kent. William and Felicia Sisley were both descended from successful smugglers and tradesmen, equally at home in France or England, where they lived in Romney Marsh, an area of Kent well known for its smuggling traffic with the Continent. As one of Sisley's relations later wrote, 'the character of his art seems to suggest an origin in French bourgeois culture rather than in rugged, English peasantry'. Alfred Sisley, who was born in Paris on 30 October 1839, had one elder brother and two elder sisters, Aline and Emily – significantly one French and one English name. Almost nothing is known of Sisley's life until he was 22; we can be sure, however, that it was comfortable and not without some cultural stimulation, for Mme Sisley apparently had musical and literary tastes, both inherited by Alfred. At the age of 16 he was working in his father's office in Paris and in 1857, when he was 18, he was sent to London for three or four years to prepare for a commercial career. However, we are told that he preferred visiting exhibitions and looked enthusiastically at Constable and Turner. He may well have seen work by French artists, for Corot and some of the Barbizon painters were beginning to be exhibited in London. It is likely that Sisley had a foretaste of work that was to influence him profoundly after his return to Paris. Probably in the autumn of 1860 Sisley entered the studio of Charles Gleyre, having persuaded his parents to allow him to study painting and abandon commerce.

Charles Gleyre (1806-74), a burly Swiss with a strong German accent, taught at the Ecole des Beaux-Arts, but had opened a studio, as did other teachers from the Ecole, to counteract the unsettling system there 'where teaching was done in rotation by the different masters without any real consistency of method'. Remembering early years of poverty in Paris, Gleyre waived aside teaching fees for his students; about 30 or 40 of them attended his atelier in the rue Vaugirard. Although Gleyre was certainly no innovator and partook of much current academic doctrine, he deserves more sympathetic attention as a teacher than has usually been given him. He was an infrequent exhibitor, a reserved, introspective man, conscious perhaps of a sense of failure in his later years and troubled by increasingly poor eyesight. He could be encouraging to his students and certainly gained their affectionate respect for his independent views and generally tolerant attitude. Like Manet's teacher, Thomas Couture, he encouraged study out of doors and painted landscape himself, but felt it was hardly the proper subject on which to base a career. It is ironic that among his students were Monet and Sisley, both outstanding practitioners of landscape in its purest form.

Gleyre's atelier is amusingly evoked in George du Maurier's novel *Trilby* (1894); the range of students was wide, running from rich young dilettantes to a freckled English girl who was all for free love and Courbet. Whistler had been a student there in the mid-1850s and acknowledged his debt to Gleyre's teaching, particularly on the preparation of the palette, on which Gleyre recommended that all tones necessary for the proposed work should be assembled, thereby facilitating quick and spontaneous painting. By 1862 four remarkable students were working at the atelier – Sisley, Claude Monet, Frédéric Bazille and Pierre-Auguste Renoir, the last-named also attending courses at the Ecole des Beaux-Arts. Monet was perhaps the least receptive to Gleyre's teaching and was already marked out as a leader; Bazille went to the atelier in the mornings and the Ecole de Médecine in the afternoons; Renoir worked industriously – 'under Gleyre I learnt my trade as a painter', he said later. All became Sisley's intimate friends – particularly Renoir (Fig. 3) – and were in close accord

Fig. 4
Jean-Baptiste-Camille
Corot
Church at Marissel
1866. Oil on canvas,
55 x 42 cm. Musée
d'Orsay, Paris

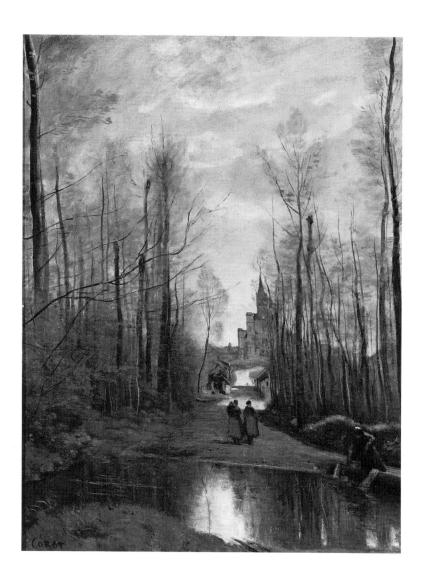

through the following years.

Of Sisley's student work nothing survives. His development during the 1860s must be deduced from only a handful of pictures. Certainly the example of Corot and Courbet meant much to him; he was perhaps introduced by Monet to the work of Boudin and Jongkind although, unlike Monet, his essentially conservative nature prevented any quick assimilation of those two painters. It was to Corot that he returned again and again, and in Sisley's one pronouncement on his painting method and attitude to landscape (in a letter to Adolphe Tavernier of 1893) he comes close to Corot's notes on his own work, even to the point where both agree to paint the sky first and to the initial importance of establishing as simply as possible the work's construction, its formal point of departure. Then the whole should be enveloped in a consistent atmosphere. Similar motifs excited Corot and Sisley – the edge of woods, or woodland clearings; roads and avenues leading towards the horizon; village corners; small anonymous figures walking or at some country pursuit, which give a sense of scale and intimacy to a landscape; or clusters of buildings by a river, often viewed through trees from the opposite bank (Fig. 4) (best seen in Corot in his late paintings of Mantes, contemporary with Sisley's early works). All these subjects were pursued and refined in later years, amplified by Sisley's increasing preoccupation with water and with aspects of weather not treated by Corot, such as frost and snow. But already we can see in such a painting as his Salon exhibit of 1868, *Avenue of Chestnut-Trees* (Fig. 5), the subdued browns and heightened

greens reminiscent of Courbet, more personally developed in the *View of Montmartre* (Plate 4) of the following year. A further influence may be detected in a painting unusual in Sisley's *œuvre*, *Still life with Heron* (Plate 3), in which the subtle blacks, greys and dusty mauves put one in mind of Manet's distinctive colour preferences. The sureness of tone that Sisley achieved here rarely deserted him.

Renoir is the chief witness to Sisley's character at this period, although several recently discovered letters by some of Gleyre's American students show Sisley to be hardworking and gregarious, living at home in the midst of a hospitable family. In 1864 Gleyre closed his school and thereafter Sisley frequently left Paris to paint at Chailly and Marlotte in the Forest of Fontainebleau. Unlike Renoir and Monet he was financially secure, having a generous allowance from his father, whose business at that time was expanding and prosperous. Sisley was known for the gentleness of his disposition, his quiet good manners and the gaiety of his humour. 'He was a delightful human being', Renoir later told his son Jean. 'He could never resist a petticoat. We would be walking along the street, talking about the weather or something equally trivial, and suddenly Sisley would disappear. Then I would discover him at his old game of flirting.' The fact that there are so few paintings by Sisley from the 1860s has usually been ascribed to his 'gentleman' status among his group of

Fig. 5
Avenue of Chestnut Trees near La Celle-Saint-Cloud
1867. Oil on canvas, 95.5 x 122.2 cm. City Art Gallery, Southampton

friends. However, two events considerably modify this explanation. In 1866, he met a young florist, Marie Louise Adélaïde Eugénie Lescouezec (1834-98); in the following year she gave birth to their son Pierre (17 June) and, two years later, to their daughter Jeanne (29 January 1869). It seems that Sisley's father disapproved of this liaison and withdrew his financial support. Sisley was no longer the affluent young man as depicted in most histories of Impressionism. He and his family moved to a house in Bougival, on the Seine just west of Paris. In the siege of the capital in the Franco-Prussian War, Bougival was overrun (1870) and Sisley lost all his possessions including, it must be assumed, a good many works from the 1860s. It is nearly always said that Sisley's penurious existence began with the financial ruin and subsequent death of his father during the war. This is not so. From about 1867 there seems to have been little contact between father and son. William Sisley certainly suffered business reversals in the War as well as ill-health. He died in 1879, leaving almost nothing.

In 1866 Sisley had two pictures hung at the Paris Salon – both Fontainebleau landscapes (Plate 2) – but in the following year, along with Renoir, Pissarro, Cézanne and Bazille, he was refused. They vainly petitioned for a new *Salon des Refusés* on the lines of the one held in 1863, where Manet's *Luncheon on the Grass* had outraged the public, and discussions began on the possibility of holding their own exhibition. In 1868 the painters secured an ally on the Salon jury in Charles Daubigny, associated with Barbizon but then living at Auvers-sur-Oise; through his stubborn advocacy, the future Impressionists were accepted.

In 1870 Sisley began the great decade of his painting. His progress was astonishing. In a few months he moved from the compact, linear *View of Montmartre* (Plate 4), essentially pre-Impressionist, to two views of the Canal Saint-Martin in Paris (both in the Musée d'Orsay). The subjects are urban, with workmen unloading barges, and characteristic Paris houses in the background. The verdant greens of Fontainebleau have been replaced by wintry trees and a distinctly chilly air. Above all, there is a new freedom in the handling of the paint, brushstrokes are more tentative, much less smoothly merged, and various areas of the canvas are differently treated to give a surface that is animated yet held together by the prevailing light. This differentiated brushstroke has long been a subject of dispute. Some commentators have seen it as a way of describing the planes and textures of the objects depicted; others as a means to an overall rhythmic animation of the picture surface itself, a way of being free in fact of any compulsion to describe. In Sisley's best works we see a synthesis of both. The rapid, exclamatory handling found so often in his treatment of water is both descriptive of the lapping, undulating surface of a flowing river and a way of describing its ceaseless reflections, broken and reformed by the current; the mobility of handling is the equivalent of the mobility of light as it captures and releases its fugitive impressions of trees, banks, boats, houses and sky. And it is this mobility – whether of grass and foliage, the passage of clouds, reflections on water, or sunlight on a building's façade – which constantly engaged Sisley's attention. Although he worked alongside Monet in the later 1860s (they were at Honfleur in the summer of 1867, for example), it is not until 1870-71 that Sisley approaches Monet's free handling of similar themes – the water in the latter's *La Grenouillère* pictures of 1869 approximates Sisley's in the *Canal Saint-Martin* paintings, though Sisley has a softer, more delicate touch and gives more suggestion of depth.

Just as Sisley was beginning to participate confidently in the new

movement, focusing his vision in line with his friends, the Franco-Prussian War dispersed the Impressionists. The convivial and argumentative evenings of discussion at the Café Guerbois, which Sisley sometimes attended, came to an end. Monet and Pissarro fled to London; Renoir was drafted into the army and nearly died of dysentery; Bazille, just beginning to find himself as a painter (Fig. 6) joined up and was killed in November 1870. For Sisley personally the war was a disaster and from this time onwards to his death in 1899 he had to struggle incessantly against poverty. Although there were a few

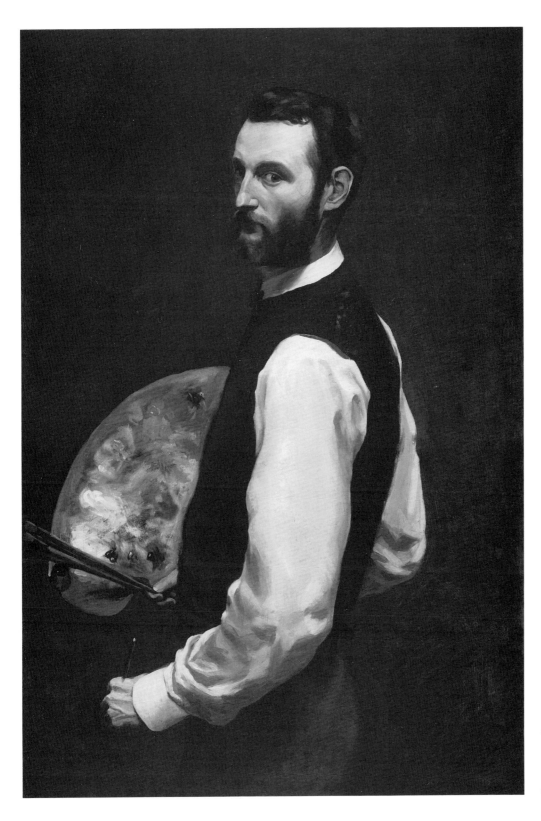

Fig. 6
Frédéric Bazille
Self-portrait
1865. Oil on canvas,
108.6 x 72.1 cm. Art
Institute of Chicago,
Chicago, IL

periods of relative calm, the search for patrons and sales hardly abated. Sisley was the only one of the original Impressionist group not to gain some measure of financial success during his lifetime. Even Pissarro, at the end of a life beleaguered by hardship, spent some years free of money troubles. However, when in desperate circumstances, Sisley had two or three friends on whom he could count. Chief among them was the dealer Paul Durand-Ruel, whom he met through Pissarro and Monet in 1871. Having dealt for some years in the work of Corot, Daubigny and the Barbizon school, Durand-Ruel identified himself with the young Impressionists (although Cézanne he refused to touch), bought their work, answered their appeals and gave them moral support. Although twice nearly ruined, he persevered, putting on exhibitions in Europe and later in New York, where he successfully opened a gallery.

Among patrons Sisley turned to were Eugène Murer, a pastry-cook and hotelier who amassed very cheaply (often as payment for meals) a large collection of Impressionist paintings; the baritone Jean-Baptiste Faure of the Opéra-Comique; and Georges Charpentier, publisher and particular patron of Renoir, whose wife's salon in the rue de Grenelle Sisley sometimes attended. Charpentier was frequently generous to Sisley, answering such appeals as this, written from Sèvres in 1879: '*Je suis dans le plus grand embarrass et je pense que vous pourrez peut-être m'aider à en sortir. J'ai besoin d'une somme de quatre cents francs. J'ai six toiles, dont cinq nouvelles chez Legrand. Si vous pouvez disposer de cette somme, et vous m'obligeriez, elles sont à vous. Votre dévoué, A. Sisley.*' ('I'm really in the most terrible fix and I wonder whether you might be able to help me out of it. I need 400 francs. I have six canvases and five of these are new ones at Legrand's. If you are able to let me have this sum of money, and I'd be greatly obliged, they are yours. Yours, A. Sisley.') Partly in order to economize (and the cost of living after the war rose steeply), Sisley and his family moved from Paris where they had fled from Bougival, first of all settling at Louveciennes (1872-5), then Marly-le-Roi (1875-7) and Sèvres (1877-80). All were within a short distance of Paris and yet were still sufficiently rural to provide innumerable subjects. In these places, in the surrounding fields and along the banks of the Seine, Sisley produced paintings which are among the most serene and confident landscapes of the century and that constitute his main contribution to Impressionism.

The word Impressionism can now be used more precisely. The war over, Sisley's friends also returned to the country around Paris or were frequent visitors – Renoir was in the capital but often visited his parents in Louveciennes, the village where Pissarro was established, and Monet was across the Seine at Argenteuil. They met regularly, worked together, and by 1873 had decided to form the *Société Anonyme des Artistes Peintres, Sculpteurs, Graveurs* (Anonymous Society of Painters, Sculptors, Engravers), which held its famous first exhibition from 15 April to 15 May 1874. Sisley participated in four of the eight Group exhibitions of the 'Impressionists', as they came to be called following a journalist's slur. By so doing, this retiring, conservative man identified himself with the most progressive movement of his day. But the scorn with which Monet, Renoir and Pissarro were treated in the press was rarely directed at Sisley. Certainly he was known as a prominent member of the group, but individual comments on his work tended to be peremptorily dismissive. He was depressed by the continually harsh reaction of the public; it was morally dispiriting and financially disastrous. But, like the others, nothing deflected him from an inner conviction that what he was

doing was right and important and would eventually be accepted.

Sisley's life and work are inextricable from the Impressionist movement, with all its legends, heroism and mythology. Indeed one writer went so far as to say that he owes his 'current prestige not to his individuality but, precisely, to his participation in a movement'. It is only natural to ask what characteristics Sisley shared with the other Impressionists and what was his relation to the wider movement of nineteenth-century realism. Must we alter our conception of Impressionism if we maintain, with several commentators, that Sisley was its most sedulous exponent? His temperament precluded any involvement with the kinds of subject that absorbed most of his fellow artists. We do not look to him for that contemporaneity of scene and detail, the spirit of '*la vie moderne*' to be found in Manet or Renoir or Degas – unless we include his paintings of the Thames regattas of 1874. Nor do we find that transcription of intimate family life, with the one exception of *The Lesson* (Plate 19), which engaged Monet or Berthe Morisot or Renoir. Unlike Pissarro, it seems he had little interest in the political movements of his day and the sympathetic fellow-feeling which pervades some of Pissarro's scenes of rural life is absent from Sisley. Figures do appear in his work – hundreds of them – but they are devoid of significance as individuals and are included as animating dashes of colour, darker accents against light fields and grass, spatial punctuation often added at a late stage in the painting. There are fishermen, bargees, housewives, children bathing or at play, washerwomen, farm-workers, huntsmen, flirting couples, strollers on summer evenings, men unloading cargo, gossiping neighbours. Sisley sees them all as inevitable presences in the essentially domestic landscape he preferred. He is in close accord here with some of the Barbizon painters, with earlier English landscape painters such as Constable and Crome, and a number of seventeenth-century Dutch artists such as Hobbema and Ruisdael.

Impressionism not only altered people's perception of their surroundings but insisted on a less exclusive, less censorious view of them. Sisley was in sympathy with this move towards a wider repertoire of subjects, a move to include hitherto neglected or 'inartistic' aspects of modern life. If a factory chimney was an essential vertical in a composition, there was no question of missing it out; if the sunlight on an iron bridge crossed by a smoky train visually excited the painter, then he pitched his easel without qualm. Bazille had written in 1866 to his parents: 'I have chosen the modern era because it is the one I understand best, that I find most alive for living people – and that is what will get me rejected.' Sisley would have heard such sentiments and discussed them at the Café Guerbois and elsewhere. And although he never went as far as Monet in his explorations of the contemporary scene (he rarely painted in Paris after 1871), he was not averse to painting wood-sawyers at work, a bridge under construction or the prosaic sand heaps on the banks of the Seine (Plate 28). In England, immediately after the first Impressionist exhibition, Sisley several times painted the new bridge at Hampton Court with its massive pillars and metal railings, even to the point of painting from underneath it, its girders filling half the canvas (Plate 21). (It is interesting to note that in contemporary guides to Hampton, the bridge is described as 'ugly' and 'disfiguring'.) Undoubtedly such a novel viewpoint can be linked to photography; it indicates that emancipation from accepted, 'classic' landscape which was finally accomplished by Impressionism. But although Sisley was not afraid to strike a subversive note where necessary, his subject-matter was invariably traditional. More than the other Impressionists, he was

Fig. 7
Place du Chenil at
Marly, under Snow
(detail)
1876. Oil on canvas,
50 x 62 cm. Musée des
Beaux-Arts, Rouen

Fig. 8
Hiroshige
Evening Snow,
Kambara, c.1830-34.
Woodblock print, 24.8 x
38.2 cm. Victoria and
Albert Museum, London

content to develop along earlier lines – there are, for instance, similarities of composition and mood with such landscape painters as François-Auguste Ravier and the gifted Antoine Chintreuil, a friend of Pissarro and admired by Redon. In some pictures there is a marked feeling for Japanese art, particularly in the snow scenes (Figs. 7 & 8) and in Sisley's combination in some works of widely differing perspectives echoing, for example Hokusai's woodblock prints of 'Bridges'. It is unlikely that he took much interest in recent scientific investigations into colour, and he remained unaffected by the Pointillism which Pissarro espoused. Anything Sisley owes to such investigations is more likely to originate from working alongside Monet and Renoir than from any theoretical application. Sisley embodies such characteristic features of Impressionism in moderation. Certainly he was stimulated to new ways of seeing and modes of expression by his early friendships with Bazille and Renoir and a little later by Monet and Pissarro. If he was not a great innovator among the Impressionists, he was distinctly of the movement and has his own particular interpretation. Without such pictures as *Under the Bridge at Hampton Court* (Plate 21), *Snow at Louveciennes* (Plate 29), *Flood at Port-Marly* (Plate 30), *Footbridge at Argenteuil* (Plate 24), Impressionism would be impoverished.

Sisley's work has too often been judged as being entirely derivative. Lionello Venturi, for example, wrote that he 'invented nothing, but created works of art. Corot, Courbet, Pissarro and especially Monet taught him many things; he, Sisley, never taught anyone anything.' The French critic Paul Jamot wrote that 'once provided with the technique transmitted by Monet, [Sisley] had no further ambition than to be the delightful minor poet of the country and seasons – nearer to Lépine (1835-92) and to Corot himself than to the author of the *Poplars* and *The Cathedrals*.' It is difficult to reconcile this view with

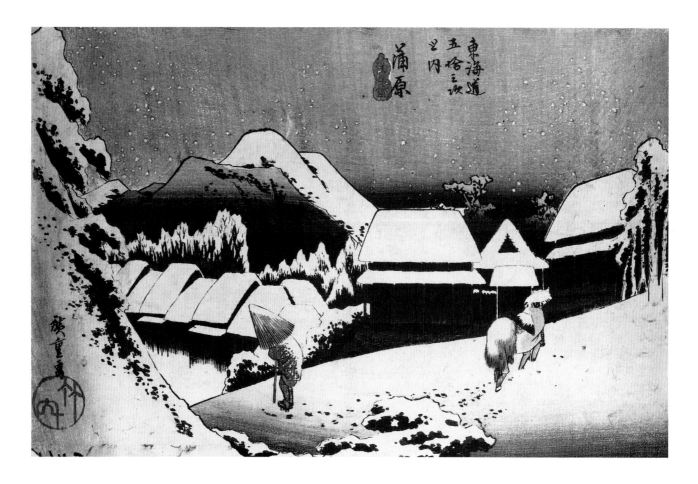

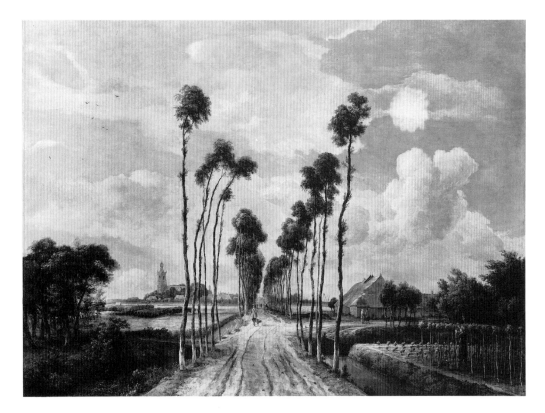

Fig. 9
Meindert Hobbema
The Avenue,
Middelharnis
1689. Oil on canvas,
103.5 x 141 cm. National
Gallery, London

such strong, individual paintings as mentioned above or the Hampton Court regatta pictures and the late views of Moret's church. Directness, simplicity, the judicious disposition of a few chosen elements characterize Sisley's best work. He avoids the plunging viewpoints of Monet's coastal paintings with their 'tumultuous pictorial fabric' no less than Pissarro's complex, architectural motifs. He is at his most convincing when a substantial, man-made structure contrasts with the surrounding fluidity of foliage, water and sky, and has an ability to situate and anchor such features with a succinct breadth of treatment, yet retain their weight and solidity. We see this most forcibly in the period 1870-80 in several paintings done at Marly-le-Roi – *The Machine* (Plate 24) and *The Aqueduct* (Plate 25) and views of the floods at nearby Port-Marly, its sturdy inn stranded between water and sky (Plates 30-32). The dramatic human implications of such a scene (for we are looking in fact at a busy main street, usually full of shops and people) are suppressed in favour of a detached lyricism where any drama is distilled in the door's black rectangle and its steady reflection. Sisley was incapable at any period of forcing his response and it is exactly this freedom from imposed feeling that gives such paintings their ability to move, surprise and enrich. All the small impressions, circuitous delights and particularities are subordinated to a total conception, as gravely measured throughout as it is flexible in its details.

Sisley was finely endowed with constructive powers and one of his special achievements was the evocation of space. He is rarely complicated in this and depends on certain compositional features which vary little in his whole output. We have already noted, in connection with Corot's influence, his predilection for roads and pathways leading into the picture; avenues of poplars and plane trees similarly engaged him and he was doubtless impressed, as François Daulte has suggested, by Hobbema's *The Avenue, Middelharnis* (Fig. 9), which he would have seen in the National Gallery during his early years in London. Sometimes his roads and paths move gradually from

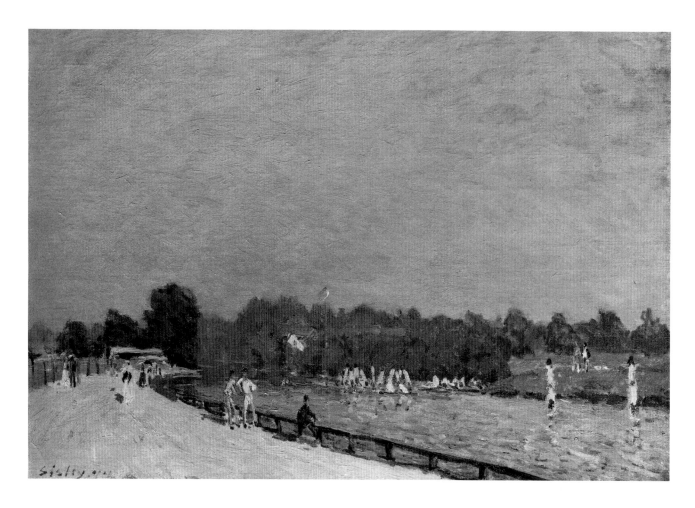

Fig. 10
The Road from
Hampton Court
1874. Oil on canvas,
38.5 x 55.5 cm. Private
collection

one side of the canvas up to the other, sometimes they open fan-like, as in the snow scenes of Louveciennes; recession is suggested by the scale of figures and their atmospheric differentiation (Fig. 10). He favours low horizons (there are no paintings entirely taken up by landscape); wide foregrounds of field, road or water, in which he often exaggerates the scale of stones, grass or ripples; a section of near detail from which the eye passes to distant vistas (Plate 12), tempering a too obvious recession; strong, interlocking horizontals crossed by verticals of trees, their reflections, fences and posts (as in several river views such as Fig. 11). But this spatial articulation cannot of course be divorced from Sisley's colour, and of all the Impressionists he had perhaps the most felicitous and perfectly pitched sense of tone, certainly during the period of about 1872-8. Although he never quite lost this sense, there are works of the 1880s where he throws a landscape into such a high colour key that the tonal adjustments falter.

In examining Sisley's colour we must keep in mind the admonishments against bright colour he would have heard at Gleyre's atelier and also his love for Corot. Renoir has recorded Gleyre's severe warnings against the use of clear, bright colour; like some distasteful vice, it was almost one's moral duty to avoid it – one might be blinded by it. The reform of Sisley's palette was a gradual process and through the early 1870s he often employed the light browns, ochres, pale blues and grey-greens which were his inheritance from Corot and from Courbet. His tonally subdued *View of Montmartre* (Plate 4) is the masterpiece of that early period. The example of Renoir (whose work in the 1860s, influenced by Diaz, astonished Sisley) and of Monet intervened, and he was launched into new discoveries of colour and handling. Shadows now revealed a multiplicity of colours, foliage was freed from the heavy chiaroscuro of Barbizon, walls of houses took on

a range of lilacs, lemons, warm blues and dusty pinks (Plate 6); village streets became matted dashes and strokes of purple, peach yellow and blue grey.

Above all, Sisley's precise sense of tone allowed him to use delicately graded blues in the suggestion of the air of a landscape and its recession towards the horizon. Corot's soft greys and silvered greens are replaced by a weft of luminous blues and lilac. But it is the sky which draws from Sisley some of his most personal colouring. In a letter to Adolphe Tavernier on his painting, Sisley wrote of the immense importance to him of the sky and how he would begin a picture with it, establishing its various planes – 'for the sky, like the ground, has its planes' – and its tonal and rhythmic relations with the lie of the land or foliage in front of it. He exactly judges the effect on the sky of a brilliant cornfield touching it and the tense dialogue of colour between the two; he gauges with perfect control the relation between snow-bound earth and a sky heavy with snow to come – through analogous tones as much as through the density of the paint textures (Plate 29). Dramatic and stormy skies are not common in his work. We find no equivalent of Daubigny's turbulent sunsets with their molten vermilions and oranges. He seems less eager to explore the extreme evanescence of sunrise and sunset, or the crepuscular effects of Whistler, or Boudin's moonlit views. Unlike Monet or Pissarro, it seems Sisley never attempted painting at night. Nevertheless his variety is impressive – from absolutely limpid summer blues gaining in density towards the zenith, to skies of great animation where swiftly moving clouds are streaked and bruised with ochre, indian red and empurpled grey. There are skies that recall Van Gogh and Vlaminck in their vehemence, where thick, square-ended brushstrokes move rapidly across areas of uniform colour; others in which Sisley uses malachite, lemon and rose to evoke the most discriminating nuances of atmospheric change. He can give us skies we have never seen before, just as Pissarro shows us earth of a palpable fertility or Monet both, in a world of water.

What is seen rather than known, what is revealed to the eye and what suppressed by light, whether from a frank and constant source or veiled, interrupted, passing – this was Sisley's continual preoccupation. And to this fundamental characteristic of Impressionism – the High Impressionism of the 1870s – he held; when we speak of the crisis of Impressionism which in the 1880s considerably altered the work of Renoir or Pissarro, we may exclude Sisley. But even during those years there are changes in his work which suggest restlessness and dissatisfaction, a willingness to sacrifice some of his most personal features to follow Renoir or Monet, and a distinct faltering of his perceptions. His essentially lyrical response flickers intermittently over the chosen subject. In the late 1880s especially, we see him trying to animate lifeless foliage and exhausted fields; even Moret in broad sunlight becomes an echo of former energies. It is in Sisley's handling of paint that these changes become most apparent. Surface was always crucial to him and he wrote of it to Tavernier:

> To give life to the work of art is certainly one of the most necessary tasks of the true artist. Everything must serve this end: form, colour, surface. The artist's impression is the life-giving factor, and only this impression can free that of the spectator.
>
> And though the artist must remain the master of his craft, the surface, at times raised to the highest pitch of liveliness, should transmit to the beholder the sensation which possessed the artist.
>
> You see that I am in favour of a variation of surface within the

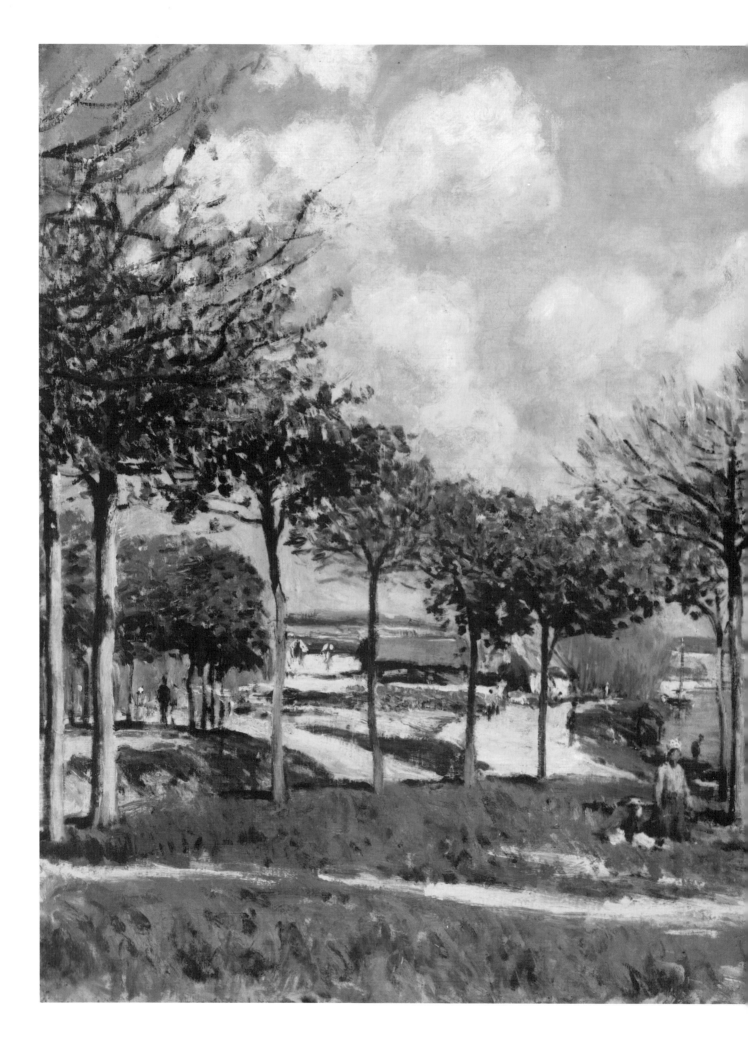

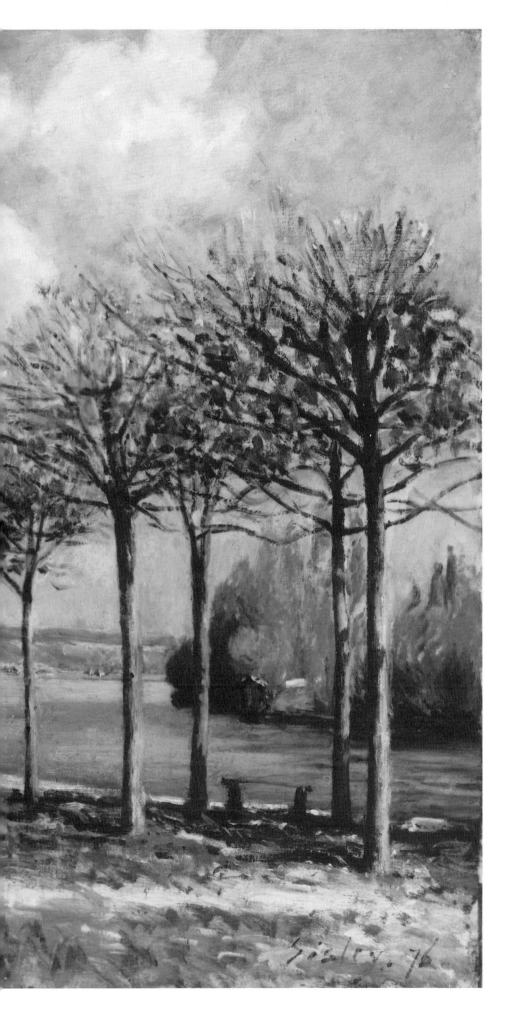

Fig. 11
The Seine at Bougival
1876. Oil on canvas,
46.4 x 61.3 cm.
Metropolitan Museum
of Art, New York

same picture. This does not correspond to customary opinion, but I believe it to be correct, particularly when it is a question of rendering light-effects. Because when the sun lets certain parts of a landscape appear soft, it lifts others into sharp relief. These effects of light, which have an almost material expression in nature, must be rendered in material fashion on the canvas.

If we look at the trees in the *Bridge at Hampton Court* (Plate 20), they are brushed in with consummate ease, shaped by generous strokes of colour, calligraphic in their relaxed rhythms; the sky is rendered even more broadly, the brushstrokes plainly visible; the river is densely textured with full, generally parallel dabs of pigment over which Sisley places longer, thinner strokes of dry, pale blue. There is variety here, but it is the result of immediate necessity and only partially directed by surface considerations. If we examine a later painting, the facture is more complex. Paint is less succulently applied, strong accents dissolve in a matted impasto; commas, dashes, spots and loops, put on with small brushes, make up a rough, agitated surface. Trees become furry and congealed, their rhythmic coherence lost in febrile scumbling. By such methods Sisley frequently creates an impression of false excitement, losing those qualities of pristine statement and unforced handling remarkable in his earlier works.

There were, however, periods of recovery, especially in the 1880s and the early 1890s. Such a painting as *The Loing at St-Mammès* of 1885 (Plate 38) is representative of a group of pictures from that year and the following one in which Sisley's colour owes something to Renoir's chromatic brilliance. Sharper colour schemes predominate – apple greens, lemons, the vermilion of roof-tops, adventurous violets and pinks, touches of Prussian blue. Some of these landscapes have the freshness of Van Gogh's first Provençal orchards (how close the compositions are of these very dissimilar painters). To the early 1890s belong further paintings to prove that Sisley, once his early lyricism had withered, was capable of renewal – among them many views of Moret seen across the river, of haystacks and of the church at Moret. Some of the paintings of the old town viewed from across the Loing are of a dream-like clarity, images of longing for landscapes of the imagination (Plate 42). Haystacks burn with chrome and purple, fertile structures in sunlit fields. Thinly painted, delicate scenes along the river, often misty or in evening sunlight, evoke the mood of Delius's elegiac music, composed at Grez, a few miles downstream from Moret (Plate 43). Of the Eglise Notre-Dame there are over a dozen paintings, done in 1893-4 at various times of the day, in different weathers, and in different seasons. Undoubtedly Monet's *Rouen Cathedral* series (1891-3) inspired Sisley, though it is doubtful if he had seen them; they were not exhibited until 1895 and Monet was well known for his secrecy and dislike of showing new work even to close friends. On the other hand Sisley may have inspired Pissarro's several paintings of Saint-Jacques, Dieppe (1901), closer to Sisley in their small-town *mise-en-scène* than to Monet's more conceptual variations. In all these works of the early 1890s, often too summarily dismissed, the combination of natural and solid, man-made elements draws from Sisley works that are tautly conceived, restrained in their handling, and showing once more what Roger Fry described as Sisley's 'infallible instinct for spacing and proportion'. Writing some years earlier (May 1887) to his son Lucien, Pissarro lamented Sisley's failure at that time: '...he is adroit, delicate enough, but absolutely false...'; and a day later: 'As for Sisley, I just can't enjoy his work, it is commonplace, forced, disordered; Sisley has a good eye, and his work

will certainly charm all those whose artistic sense is not very refined.' Such judgments are appropriate to much of the work of the late 1880s; but Pissarro later wrote (22 January 1899, a week before Sisley's death): 'He is a great and beautiful artist, in my opinion he is a master equal to the greatest. I have seen works of his of rare amplitude and beauty, among others an *Inundation*, which is a masterpiece.'

Towards the end of his life, Sisley became increasingly withdrawn and unpredictable, alternating between extreme affability and black moods of suspicion and distrust (Fig. 12). His poor health gave him a good excuse for no longer attending Impressionist gatherings in Paris or meetings of the Société Nationale to which he had been elected in 1890. He occasionally saw Pissarro and visited Monet at Giverny but Renoir, at the time of Sisley's death, acknowledged that he had not seen his old friend for over 15 years. Poverty continued to restrict his life and travel was only feasible through the generosity of his patron and collector François Depeaux. In the 1890s when modest acclaim came his way, Sisley could be cheerful and stimulating company, as the critic Gustave Geffroy discovered on a visit to Moret. After several years in the vicinity of Moret, the Sisleys had moved into the town in November 1889. Sisley's final home was a small house with a garden in the rue Montmartre, close to the church. Geffroy describes the splendid welcome and luncheon he was given, and the rooms of the house piled with canvases. He was struck by Sisley's resigned dignity, good manners and cultivated conversation. Leclercq mentions as Sisley's English inheritance '*une certaine correction de tenue et des faux-cols irréprochablement blancs*' ('a certain correctness of appearance and impeccably white collars'). We learn from Huyghe that he was well read and adored music: '...he went assiduously to the Pas de Loup concerts and...music was an obsession with him: he sang unceasingly, hummed "that gay, melodious and enthralling phrase that became a part of me" from the scherzo of a Beethoven Quartet.'

Sisley left France three times after his initial stay in London as a young man. He spent four months in England in 1874 on a visit financed by Jean-Baptiste Faure and produced the celebrated series of paintings of Hampton Court. In June 1881 he went to the Isle of Wight but it was an abortive visit, his canvases failing to arrive from Paris. His last absence from France was on a visit to South Wales in 1897 when he regularized his long liaison with Eugénie by marrying her in the Cardiff Registry Office. He first visited Falmouth in Cornwall before settling at Penarth, just south of Cardiff, overlooking the Bristol Channel (Fig. 41), and later at Langland Bay. It was the first occasion on which he had painted the sea – often seen from the cliff-tops, intrepid bathers below on the shingled beach of Langland Bay, enormous rocks perched at the water's edge (Plate 48): all subtle meditations on the changing surface and colour of the sea stretching to imperceptible horizons. One can only regret that Sisley took up this subject so late in his life. There is also from this stay a sketch-book of vivid drawings, and several letters to Geffroy and Tavernier describing his contentment with his lodgings (save for impossible beds) and the superb coastline.

In October Sisley returned to Moret and in the following year it was discovered that he was suffering from cancer of the throat. On 8 October 1898 Eugénie Sisley died of cancer of the tongue. 'Sisley was the soul of devotion,' Renoir recounted, 'looking after her tirelessly, watching over her as she lay in her chair trying to rest.' Sisley's health rapidly dwindled until he was hardly able to turn his head and certainly unable to paint. In the New Year he sent for Monet to ask him to take care of his children, and a week later, on 29 January 1899,

he died. He was buried in Moret cemetery in the presence of Monet, Renoir, Adolphe Tavernier, the painter Cazin and local dignitaries. In 1911 a bust was erected in Moret to his memory.

In a passage on the landscapes of Ruisdael, written in 1875, Eugène Fromentin wrote of the Dutch painter as a dreamer, 'one of those men of whom many exist in our own day but who were rare in Ruisdael's time – one of those lonely wanderers who flee from the town, frequent the outskirts, who love the country without exaggeration and describe it without phrases, who are made uneasy by distant horizons but are charmed by open country, moved by a shadow and enchanted by a shaft of sunlight'.

He goes on to suggest the sombre reasonableness of Ruisdael's melancholy, the product neither of self-indulgent immaturity nor of the fretful self-pity of old age. No-one familiar with Sisley's painting or his character can fail to be reminded of them by Fromentin's words.

They were written in the year when Sisley produced some of his finest paintings, and at the start of one of the most discouraging periods of his life. He was at the height of his powers, superbly endowed with gifts that place his achievements on a level with those of Renoir, Monet and Pissarro. In particular, he faultlessly conveys those startling moments of perception in which a scene is removed from its surroundings and steeped in an undefinable emotion – the Marly aqueduct, the flooded inn by the Seine, a passer-by in the snow, a girl swinging in an orchard, a wave breaking over a rock on the shore. He has the power of transcribing such scenes as though he had been searching for them all along, and yet he reveals them with an air of diffidence that disarms while it captivates. It is at such moments that Sisley enlarges our perception of Impressionist painting and joins the ranks of the great European landscapists.

Fig. 12
Clement Maurice
Photograph of Alfred
Sisley
c.1892-4. Archives
Durand-Ruel, Paris

Outline Biography

The following outline is extracted from
R. Shone, *Sisley*, London, 1992, which, in parts,
supersedes previous biographical information.

1839 Born on 30 October at 19 rue des Trois
Bornes, Paris, to English parents, William
and Felicia Sisley; youngest of four
children.

1857-60 In London, preparing for a career in
commerce.

1860-63 Returns to Paris and studies in the
atelier of Charles Gleyre; meets Bazille,
Renoir and Monet.

1865 Painting in the Forest of Fontainebleau
with Renoir; several subsequent visits up
to c.1868.

1866 Two paintings exhibited at the Salon.

1867 His son Pierre is born to Marie Louise
Adélaïde Eugénie Lescouezec.

1868 One work exhibited at the Salon.

1869 Birth of daughter, Jeanne.

1870 Two works exhibited at the Salon.
Loses his possessions when the Prussian
army overruns Bougival, west of Paris,
where he is living.

1870-72 In Paris.

1872 Moves with family to Voisins, hamlet
adjoining Louveciennes, west of Paris.
Paul Durand-Ruel begins to deal in his
work.

1874 Exhibits in the first Impressionist
Exhibition. Summer spent in England at
Hampton Court. Moves to Marly-le-Roi,
close to Louveciennes, winter 1874-5.

1876 Exhibits in second Impressionist
Exhibition.

1877 Moves to Sèvres on the Seine west of
Paris. Exhibits in third Impressionist
Exhibition.

1880 Moves to the area of Moret-sur-Loing on
the edge of the Forest of Fontainebleau.

1881 Solo exhibition at La Vie Moderne, Paris.
In June visits Isle of Wight.

1882 Exhibits at the seventh Impressionist
Exhibition.

1883 Solo exhibition at Galerie Durand-Ruel,
Paris. Moves to village of Les Sablons,
outside Moret.

1888 The French State purchases a painting.

1889 Durand-Ruel organizes 'Works by Alfred
Sisley' in his New York gallery. Moves
into Moret.

1890 Elected member of the Société Nationale
des Beaux-Arts and shows annually at its
exhibitions in Paris to 1895 and again in
1898.

c.1892 Installed in his last home in Moret, 19
rue Montmartre.

1893 Painting visit to Normandy.

1897 Large retrospective exhibition held in
February at the Galerie George Petit,
Paris. Early July to early October in
England and South Wales; marries
Eugénie Lescouezec in Cardiff (5 August).

1898 Death of Mme Sisley in October.

1899 Dies on 29 January at his home in Moret.

1911 Memorial to the artist unveiled in Moret-
sur-Loing (11 July).

Select Bibliography

For further bibliographies (ie periodical literature, reviews, etc.) readers are referred to Daulte, 1959, Shone, 1992 and Stevens, 1992.

Leclercq, J., 'Sisley', *Gazette des Beaux-Arts*, March 1899, pp.227-36

Geffroy, G., *Sisley*, Paris, 1923 (enlarged second edition, 1927)

Huyghe, R., 'Lettres Inédites de Sisley', *Formes*, Paris, November 1931

Besson, G., *Sisley*, n.d. (c.1934)

Sisley, C., 'The Ancestry of Alfred Sisley', *The Burlington Magazine*, London, Vol.91, September 1949, pp.248-52

Daulte, F., *Alfred Sisley*, catalogue raisonné, Lausanne 1959

Daulte, F., *Alfred Sisley*, Milan, 1972 (English edition, 1988)

Cogniat, R., *Sisley*, Naefels, 1978

Gache-Patin, S. and Lassaigne, J., *Sisley*, Paris, 1983

Lloyd, C., *Retrospective Alfred Sisley*, exhibition catalogue, Tokyo, Fukuoka, Nara; Japan, 1985

Reed, N., *Sisley and The Thames*, London, 1991

Shone, R., *Sisley*, London, 1992

Stevens, M.A. (ed.), *Alfred Sisley*, exhibition catalogue of the 1992-93 retrospective, London, Paris, Baltimore; London and New Haven, 1992

List of illustrations

Colour Plates

24　The Machine at Marly
　　1873. Oil on canvas, 45 x 64.5 cm. Ny Carlsberg
　　Glyptotek, Copenhagen

25　The Aqueduct at Marly
　　1874. Oil on canvas, 54.3 x 81.3 cm. Toledo
　　Museum of Art, Toledo, OH

26　Fête Day at Marly-le-Roi (formerly The
　　Fourteenth of July at Marly-le-Roi)
　　1875. Oil on canvas, 54 x 73 cm. Cecil Higgins Art
　　Gallery, Bedford

27　View of Marly-le-Roi – Sunshine
　　(formerly View of St-Cloud)
　　1876. Oil on canvas, 54.2 x 73.2 cm. Art Gallery of
　　Ontario, Toronto

28　Sand on the Quayside, Port-Marly
　　1875. Oil on canvas, 46 x 65 cm. Private collection

29　Snow at Louveciennes
　　1875. Oil on canvas, 61 x 50.5 cm. Musée d'Orsay,
　　Paris

30　Flood at Port-Marly
　　1876. Oil on canvas, 50 x 61 cm. Musée des Beaux-
　　Arts, Rouen

31　Boat in the Flood at Port-Marly
　　1876. Oil on canvas, 50.5 x 61 cm. Musée d'Orsay,
　　Paris

32　Flood at Port-Marly
　　1876. Oil on canvas, 50 x 61 cm. Thyssen-
　　Bornemisza Collection, Madrid

33　Station at Sèvres
　　c.1879. Oil on canvas, 15 x 22 cm. Private collection

34　Snowy Weather at Veneux-Nadon
　　c.1880. Oil on canvas, 55 x 74 cm. Musée d'Orsay,
　　Paris

35　Orchard in Spring – By
　　1881. Oil on canvas, 54 x 72 cm. Museum
　　Boymans-van Beuningen, Rotterdam

36　Small Meadows in Spring – By
　　c.1881. Oil on canvas, 54 x 73 cm. National Gallery,
　　London

37　Matrat's Boatyard, Moret-sur-Loing
　　c.1883. Oil on canvas, 38 x 55 cm. Musée
　　départementale de l'Oise, Beauvais

38　The Canal du Loing at St-Mammès
　　1885. Oil on canvas, 74.9 x 93.3 cm. Philadelphia
　　Museum of Art, Philadelphia, PA

39　Courtyard of Farm at St-Mammès
　　1884. Oil on canvas, 73.5 x 93 cm. Musée d'Orsay,
　　Paris

40　Provencher's Mill at Moret
　　1883. Oil on canvas, 54 x 73 cm. Museum
　　Boymans-van Beuningen, Rotterdam

41　Snow Scene, Moret Station
　　1888. Pastel, 18 x 21.5 cm. National Gallery of
　　Scotland, Edinburgh

42　Moret-sur-Loing
　　1891. Oil on canvas, 65 x 92 cm. Private collection

43　The Canal du Loing at Moret
　　1892. Oil on canvas, 73 x 93 cm. Musée d'Orsay,
　　Paris

44　View in Moret (rue des Fosses)
　　1892. Oil on canvas, 38 x 46 cm. National Museum
　　of Wales, Cardiff

45　The Church at Moret in Morning Sun
　　1893. Oil on canvas, 80 x 65 cm. Kunstmuseum,
　　Winterthur

46　The Church at Moret – Icy Weather
　　1893. Oil on canvas, 65 x 81 cm. Private collection

47　The Church at Moret
　　1894. Oil on canvas, 100 x 81 cm. Musée du Petit
　　Palais, Paris

48　Langland Bay, Storr's Rock – Morning
　　1897. Oil on canvas, 65 x 81 cm. Kunstmuseum, Bern

Text Illustrations

Comparative Figures

All 1991 photographs are by the author

1 Lane near a Small Town

c.1864-5. Oil on canvas, 45 x 59.5 cm. Kunsthalle, Bremen

Of Sisley's student work nothing survives. This modest landscape appears
to be his earliest extant painting. As such, it must bear that burden of
scrutiny so often loaded upon an artist's earliest efforts. However crude or
self-conscious, such works act as touchstones for an artist's future
development – Pissarro's early, stiff drawings made in Venezuela certainly
contain intimations of his later themes and approach, as do Van Gogh's
studies of peasants and the Dutch countryside before he went to France.
Sisley's landscape – a view of a road, bordered by trees, passing through
fields to the distant outskirts of a village – finds him in characteristic voice.
The *Lane* is sober, a little tentative, nods to Holland, hints at Constable,
bows to Corot ('*élève de Corot*' was how Sisley styled himself at the Salon of
1866). It announces Sisley's taste for cultivated country rather than for the
wilder or more remote aspects of landscape, and for the recurring motif of
open foreground receding, via road or path or river, to a low horizon. The
people working in the fields on the left are prototypes of hundreds of such
figures in later paintings.

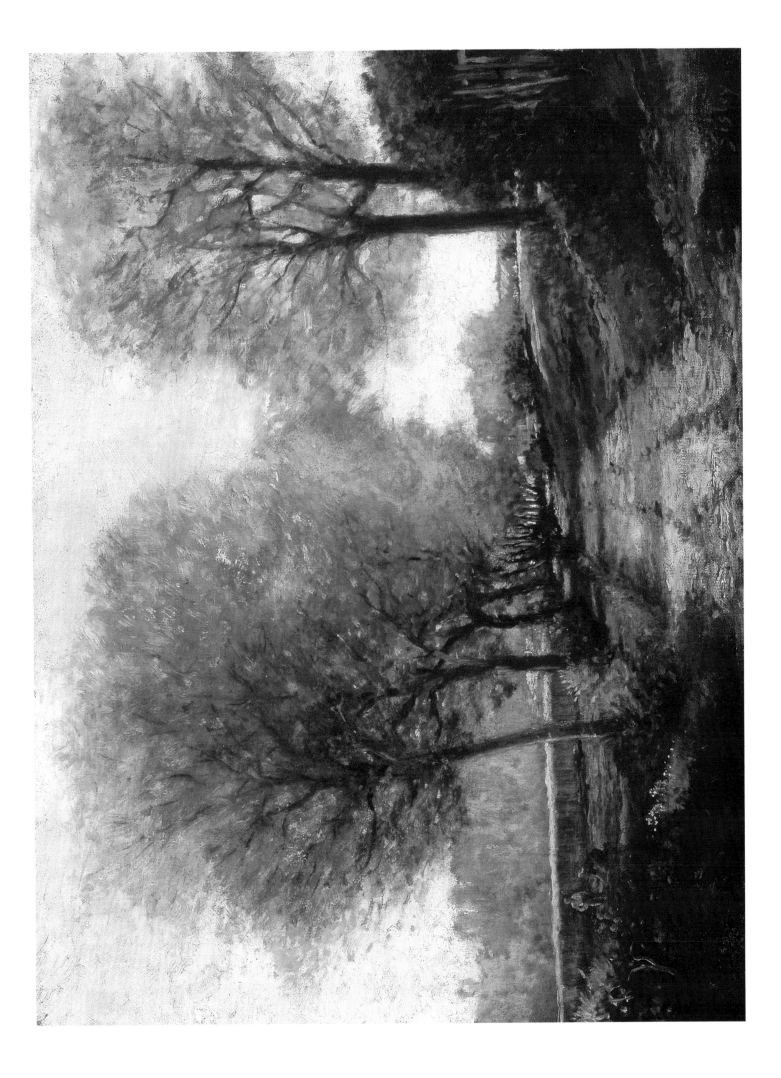

Village Street in Marlotte

1866. Oil on canvas, 50 x 92 cm. Albright-Knox Art Gallery, Buffalo, NY

In comparison with the early works of his contemporaries at Gleyre's atelier, Sisley's are decidedly quiet and unadventurous. Where Renoir, Monet and Bazille have superb paintings to their credit from the 1860s, Sisley's few pictures hardly presage the creative confidence and achievements of the early 1870s onwards. They do, however, carry those characteristics of detachment, integrity and scrupulous attention to tone which are hallmarks of Sisley's later work. *Village Street in Marlotte* perfectly embodies these elements.

It was probably carried out in the autumn of 1865 on one of his frequent painting trips to the Forest of Fontainebleau. Marlotte was already a well-known location for landscape painters and in 1865 Sisley's and Renoir's friend, Jules Le Coeur, had bought a house in the village. Once more, Sisley reminds us of his affiliations with Constable and the even more direct influence of Corot. With the English artist, he shares a similar self-effacement and allows his reactions to the scenes before him to evolve their own significance. Connections with Corot run deeper. Both painters pitch their easels at the edge of a wood or by the side of a road entering a village (as here and in its pendant painting, *Woman going to the Woods*, also shown at the 1866 Salon); both place country figures in an intimate but undramatic relation to their surroundings. They show a similar pleasure in the contrast of sunlit or light coloured buildings seen against massed foliage below skies that fill nearly half the canvas (see Plate 5).

Still Life with Heron

1867. Oil on canvas, 81 x 100 cm. Musée Fabre, Montpellier

This beautiful painting is one of only a handful of still lifes (nine are recorded) made by Sisley. It was painted in Frédéric Bazille's studio in Paris at 9 rue de la Paix. Bazille working on the same subject (*The Heron*, Musée Fabre, Montpellier) was painted by Renoir (*Portrait of Frédéric Bazille*, Musée d'Orsay), the three pictures recording the close working friendship of the three painters, in the city as much as in the Forest of Fontainebleau. Sisley's detachment and subtle tonalities are entirely his own but the distinctive colour range is reminiscent of Manet as is the broad, creamy handling of paint. Bazille greatly admired Manet and the older painter became an unofficial mentor to the group of younger artists. Sisley's remarkable still life is the only one of his works, however, to echo some of the still lifes found in Manet's figure compositions of the 1860s.

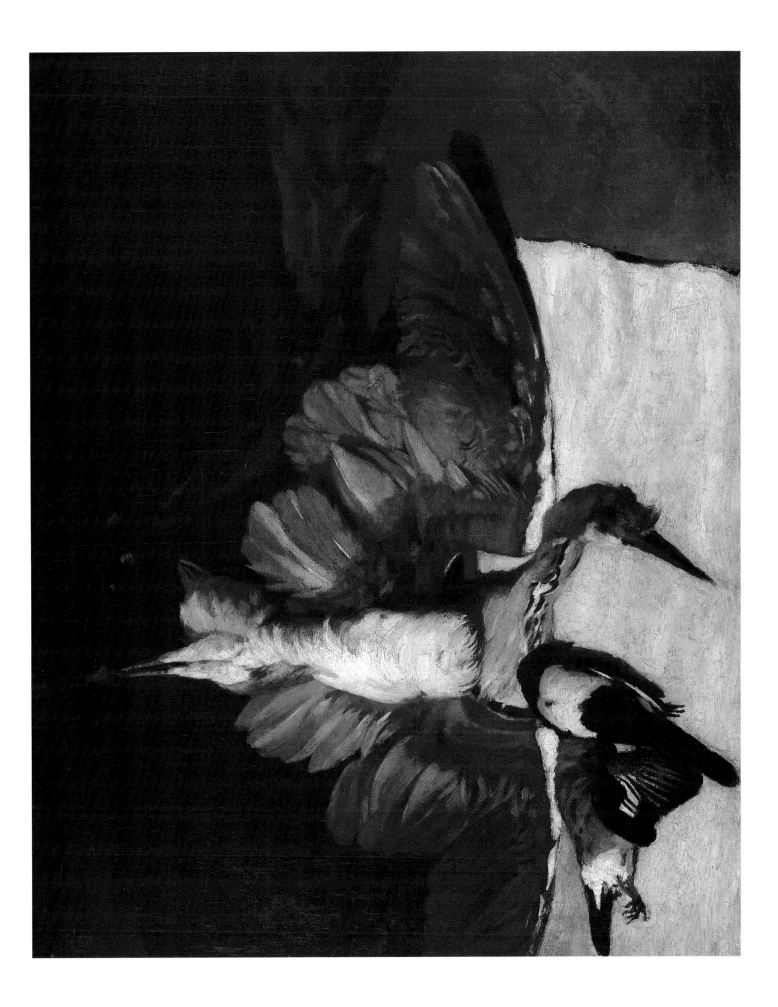

1869. Oil on canvas, 70 x 117 cm. Musée des Beaux-Arts, Grenoble

Sisley rarely painted in Paris: his vocation as landscape painter was firmly fixed from the start. When he did, sky and water predominate over buildings and urban life (as in the two paintings of the Canal Saint-Martin and that of the Pont de Grenelle, all of 1870). In this painting he is looking towards the famous Butte de Montmartre, not yet swallowed up in the northern districts of Paris. His address at this time was 27 cité des Fleurs, a flat registered in the name of his mistress, Eugénie Lescouezec, between 1867 and 1873 (by which date Sisley and his family had definitively moved out of Paris). The work of Corot and Courbet (compare the present painting with the latter's *View of Ornans* of c.1858) informs Sisley's viewpoints and muted colour at this time; indeed he is closer to Corot here than he is to the swiftly developing work of his contemporaries such as Renoir and Monet.

Nevertheless, the true Sisley breaks through at every point – from the quiet personal placing of the central motif behind a group of newly planted trees to the expansive and unsettled sky, from the modest objectivity of mood to the unemphatic situation of his figures. All these hallmarks of his style and approach were retained to the end and found their fullest expression in many views of Moret-sur-Loing from the 1880s and early 1890s.

Early Snow at Louveciennes

c.1871-2. Oil on canvas, 54 x 73 cm. Museum of Fine Arts, Boston

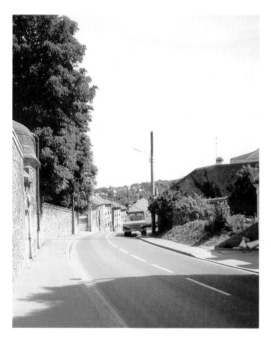

Fig. 13
Rue de Voisins,
Louveciennes, 1991

This is one of Sisley's earliest depictions of the village of Louveciennes, on high ground above the Seine to the west of Paris. It and the nearby village of Marly-le-Roi became the centre of his world until he moved to Sèvres in 1877.

Sisley positioned himself in the rue de Voisins, one of the principle streets of the village; the entrance to the château can be seen at the left and the view remains much the same today (Fig. 13). Pissarro, who briefly returned to the village in 1871-2 after exile in England during the Franco-Prussian War, painted his *Village Street, Louveciennes* (Fig. 14) from the same viewpoint on a sunny, late autumn day. It is difficult to pinpoint when Sisley painted his view – the trees are still in leaf, although tinged with brown; this suggests that snow fell before Christmas 1871 and thus the work was painted on a visit to Louveciennes before Sisley's move there in the following year. In handling and composition the work compares with *Footbridge at Argenteuil* (Plate 8) and carries the same early form of Sisley's signature. This would place the picture in late 1872. But whatever the date and detail of its conception, the work remains a masterpiece of the snow-scene genre from the early 1870s – a subject already tackled by Monet and Pissarro. It was to inspire Sisley continually during the following decade and his records of villages and landscape under snow are an individual contribution to early Impressionism.

Fig. 14
Camille Pissarro
Village Street,
Louveciennes
1871. Oil on canvas,
46 x 55.5 cm. Manchester
City Art Gallery

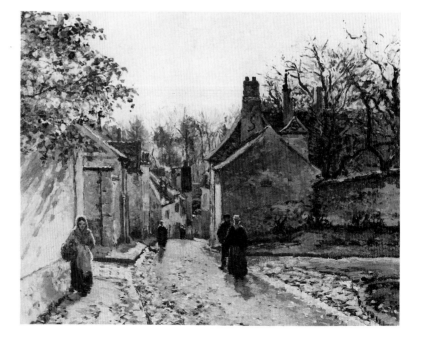

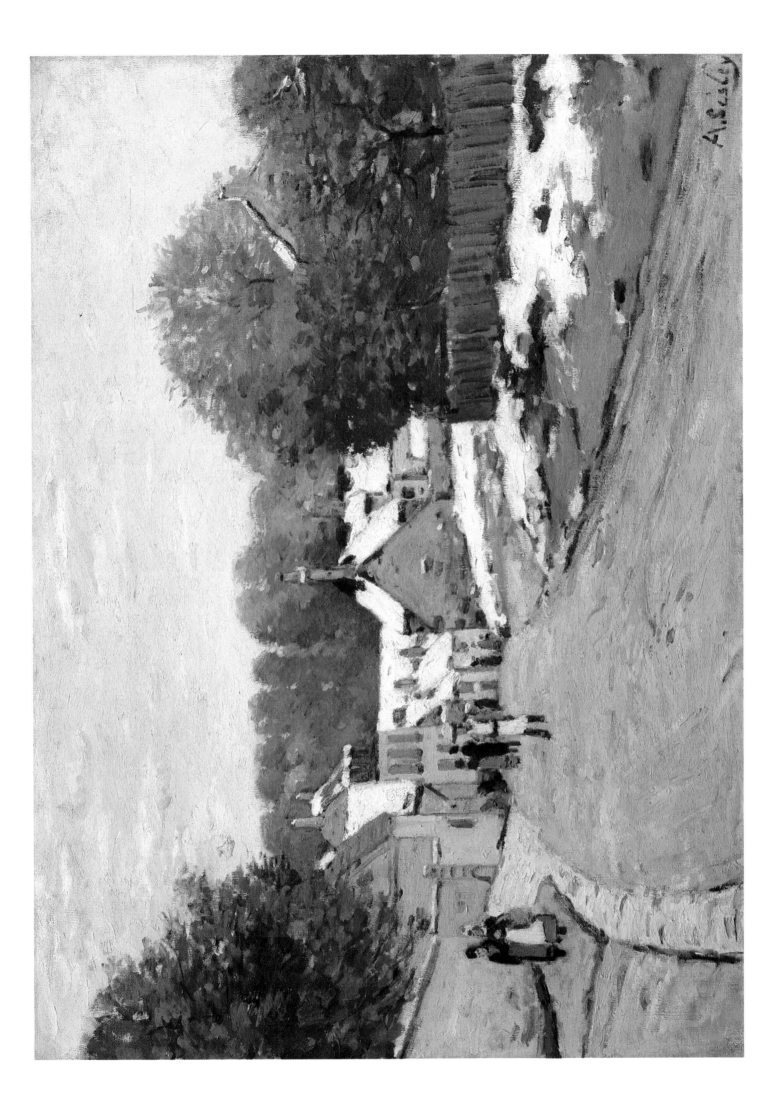

Square in Argenteuil (rue de la Chaussée)

1872. Oil on canvas, 46.5 x 66 cm. Musée d'Orsay, Paris

Sisley's close friend Monet had moved in December 1871 to the village of Argenteuil on the north bank of the Seine. Judging from the number of paintings of the village and adjacent river, Sisley must often have visited Monet there and on at least two occasions the artists set up their easels side-by-side. The works have often been reproduced together – this painting with Monet's *Rue de la Chaussée* (1872; formerly Landrin Collection, Paris) and Sisley's Boulevard Héloïse (Plate 7) with Monet's work of the same title (1872; Yale University Art Gallery, New Haven). In both cases, Sisley's paintings appear superior – more compositionally balanced and succinct in atmospheric observation. This is especially true of Sisley's *Square in Argenteuil* with its Corot-like tonality and air of desultory, late afternoon sun, its perfect green shutters and shy, gawping children.

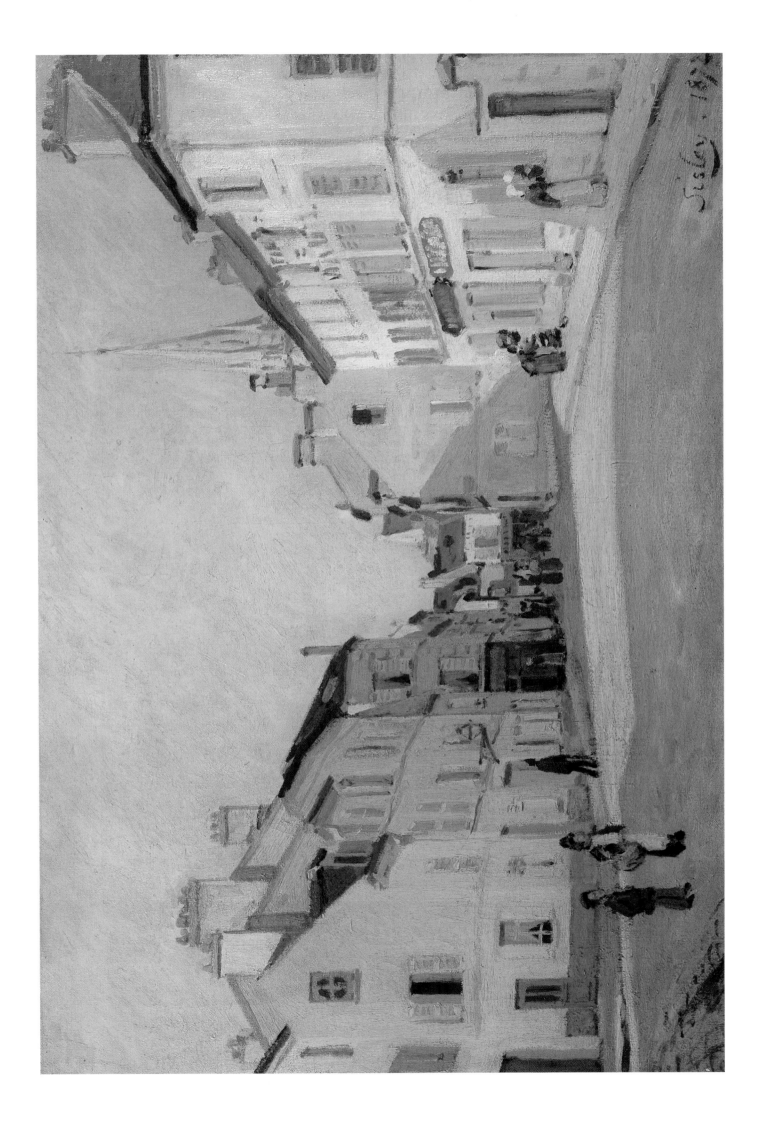

Boulevard Héloïse, Argenteuil

1872. Oil on canvas, 39 x 61 cm. National Gallery of Art, Washington, DC

The composition of this winter painting is highly characteristic in its sharply receding road balanced by the tall vertical of the trees on the right and the overlapping rectangles of the façades of houses bordering the street on the left. With typical bravura, Monet, painting alongside Sisley (see the note to the previous plate) put up his easel almost in the middle of the road; Sisley, as usual, took a position on the side, drawing out more completely the contrast of horizontal and vertical and allowing for a closer inspection of the horse-drawn vehicles and passers-by. He even extracts a note of wry amusement from the similarity between the brown horse's legs and those of the driver and the two men on the pavement.

Working in the rapidly expanding villages to the west of Paris, Sisley concentrated on a series of views of semi-rural streets. Even here, in busy Argenteuil, he suggests the equation of built-up town and nearby country (the distant trees and smock-clad carter). Later, in Louveciennes and Marly, he subtly draws attention to the impact of Paris on the small communities – from the remains of Louis XIV's château at Marly to the new villas on the route de Versailles, from traditional market gardeners at work (supplying the capital) to the pleasure-boating of weekend visitors. Only when he moved much further away to Moret-sur-Loing do we enter a more self-contained, untouched rural world.

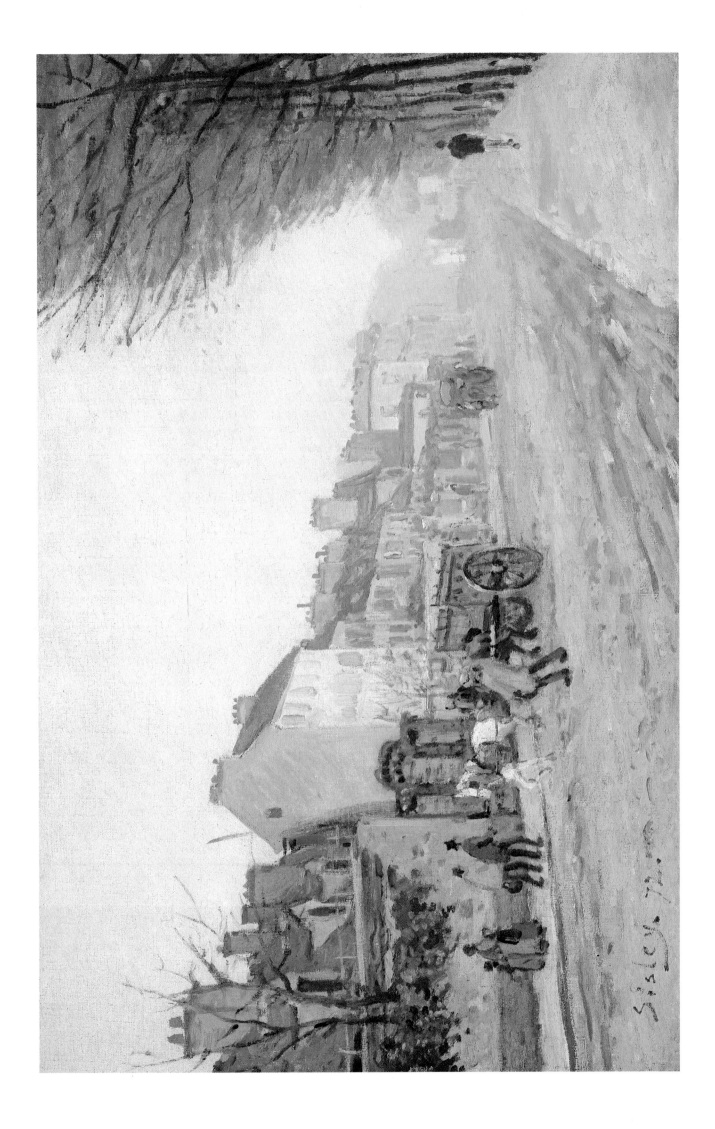

1872. Oil on canvas, 39 x 60 cm. Musée d'Orsay, Paris

This is the first appearance in Sisley's work of a bridge, a motif that preoccupied him for the rest of his life, whether at Villeneuve-la-Garenne (Plate 10) or Hampton Court (Plates 20 and 21), at St-Mammès or Moret (Plate 40). Most commonly, the bridge juts or even leaps towards the centre of a painting, giving, as here, a dramatic intensity to the mixed perspectives and superimposed planes that result. Sisley's inspiration may have come from the great Japanese print-maker Hokusai, especially his series of bridges (c.1827-30). Although there is no documentary evidence of Sisley taking a particular interest in Japanese art, with enthusiastic friends such as Monet, the critic Théodore Duret and the artist Félix Bracquemond, he could hardly have ignored it. The influence shows above all in the snow scenes of Louveciennes and Marly; but it persists throughout his work, never as overt as it is in Monet or Van Gogh, but subtly digested and transformed. Even Hokusai's small figures, going about their business and dwarfed by the landscape, are echoed by Sisley, sometimes with an arresting, even slightly comic accent, such as the staring man in this painting, whose figure appears to be repeated walking along the bridge.

Although small in dimensions, *Footbridge at Argenteuil* has all the classic features of Sisley's compositional strategies of this period. It seems to form a pair with *Boulevard Héloïse, Argenteuil* (Plate 7), where the muddy road is treated similarly to the choppy river and where the figures are astutely placed to provide accents within the compact structure of the whole.

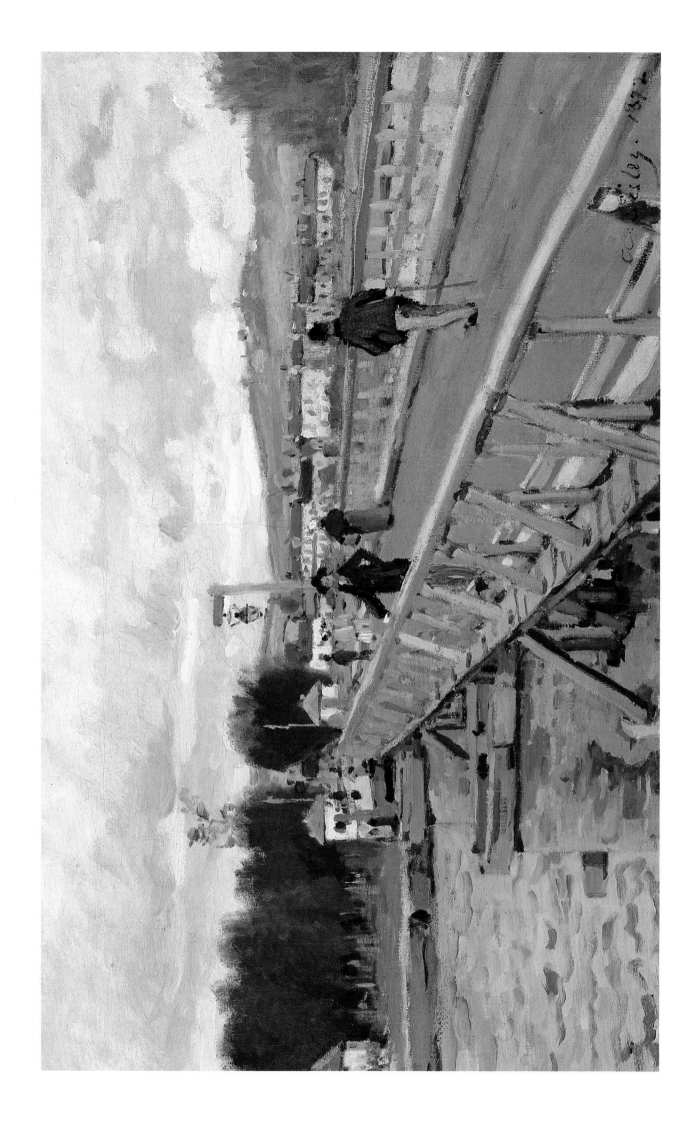

9 La Grande-Rue, Argenteuil

c.1872. Oil on canvas, 65.4 x 46.2 cm. Castle Museum, Norwich

The church of Notre-Dame rises in the background between the houses of one of Argenteuil's small streets, its spire forming one tip of a triangle made by the two disruptive horse-drawn vehicles and the lines of the pavement. Here Sisley shows the more picturesque aspect of Argenteuil (Fig. 15) in contrast to the wide boulevard of *Boulevard Héloïse, Argenteuil* (Plate 7). It has been persuasively suggested that Sisley may have had in mind Corot's similar view of the belfry at Douai (1871, Musée du Louvre) shown in Paris in the winter of 1871-2. Certainly the compositions have similarities but Sisley's viewpoint is much less magisterial. In Corot we are surveying the scene from an upper window; Sisley places us right in the street, less vertiginous and more humdrum in approach. We can sense the damp cloudy day, see the water in the gutter, a trotting dog, a woman in white cap and apron and gossiping passers-by. The placing of the two dark areas made by the carriage and the covered wagon strike a note of aesthetic contemporaneity, like the impressive black door in *Flood at Port-Marly* (Plate 32).

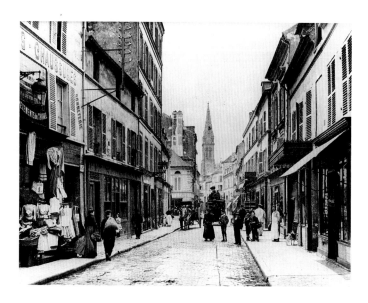

Fig. 15
La Grande-Rue,
Argenteuil, c.1900

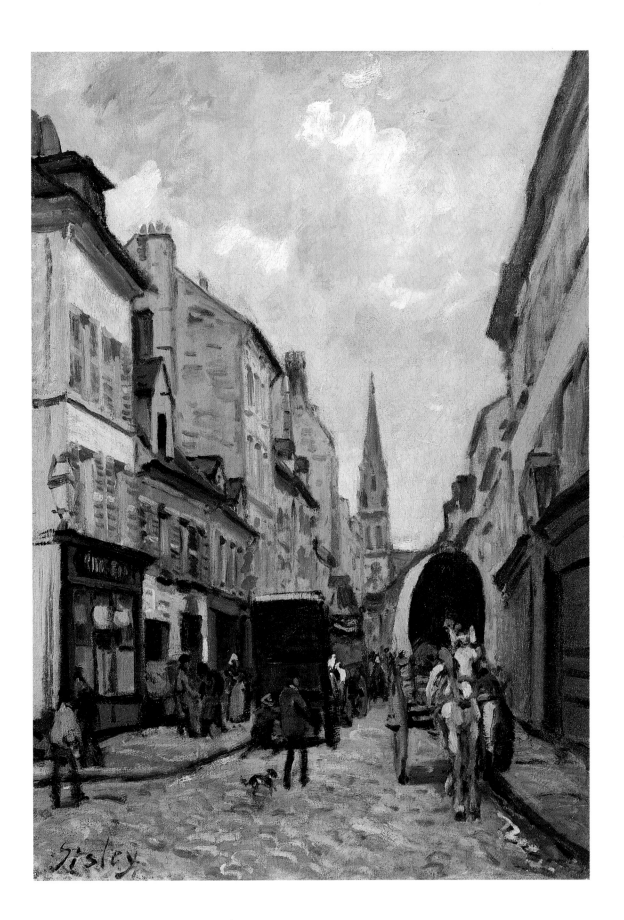

1872. Oil on canvas, 49.5 x 65.4 cm. Metropolitan Museum of Art, New York

Villeneuve-la-Garenne, a small village on the Seine, lies upstream from Argenteuil and opposite the Ile Saint-Denis. Sisley painted here on several occasions in 1872 (see Plate 11) and in the present work produced one of the quintessential summer landscapes of the early Impressionist movement. It combines audacious composition with the modest trappings of leisure – a couple relax on the bank, two women set off in a hired boat under the bridge. The heat of the summer day is further suggested by the pink awning protecting the shopfront of the main building. The cool grey of the toll-house in the centre acts as a foil for the strident green shutter and brilliant blue sky.

Apart from the daring placing of the bridge which swoops into the picture, Sisley's new-found confidence in the handling of bright colour and his differentiated textures are found throughout the painting. *Bridge at Villeneuve-la-Garenne* can be seen as the prototype of several bridge and river compositions, a scintillating trial run for *Bridge at Hampton Court* (Plate 20) of two years later.

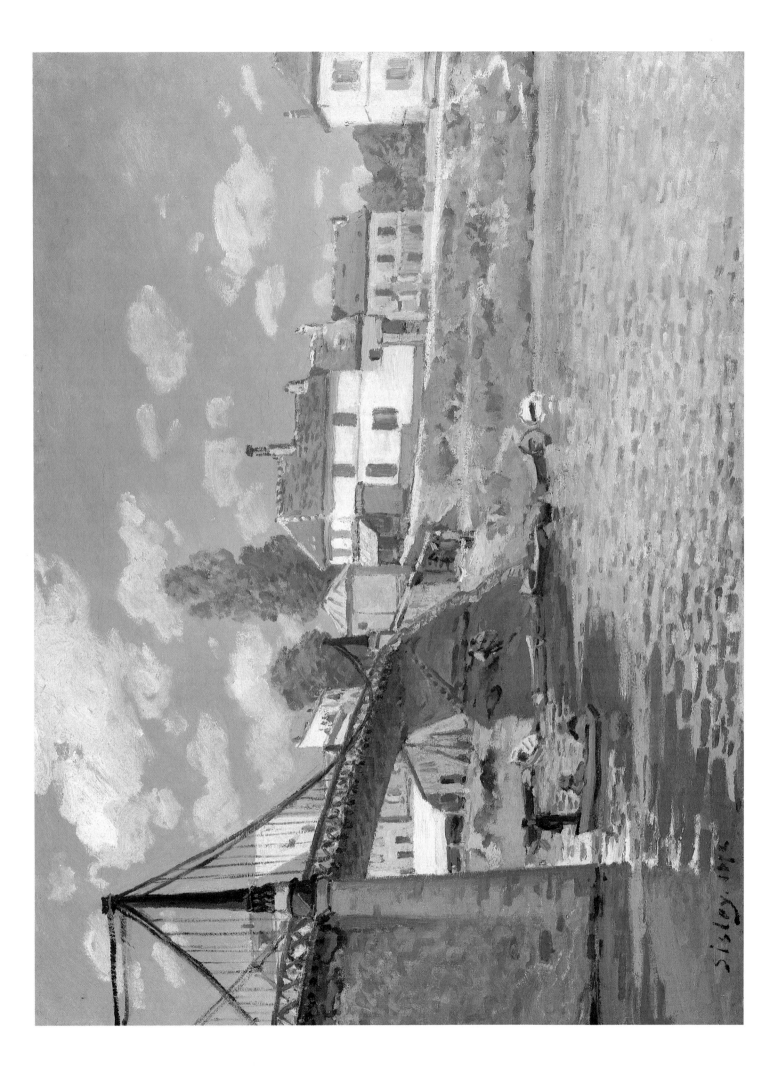

Village on the Banks of the Seine
(Villeneuve-la-Garenne)

1872. Oil on canvas, 60 x 81 cm. Hermitage, St Petersburg

For this classic composition of houses seen across a river and framed by trees, Sisley was indebted to Corot. Throughout his career, Sisley turned to the earlier master's example adding, as the years went by, his own subtle meditation on colour, light and atmosphere. In the present work, his scheme is unelaborate and full of that frank simplicity of approach that characterizes many of his earlier works. Out of the picture, to the left, is the bridge of Villeneuve-la-Garenne seen in the previous painting (Plate 10). The two houses on the right of that work are the two on the left of this. If Sisley's dating of the two pictures is correct, it would seem that his handling of sunlight, the changing reflections in moving water and the articulation of the planes of the houses was carried out with more confidence in the earlier painting. There are, throughout Sisley's work, moments of regression when he appears to falter. The trees and foreground here are painted with a certain conventionality. Nevertheless he presents an image of serene summer tranquillity.

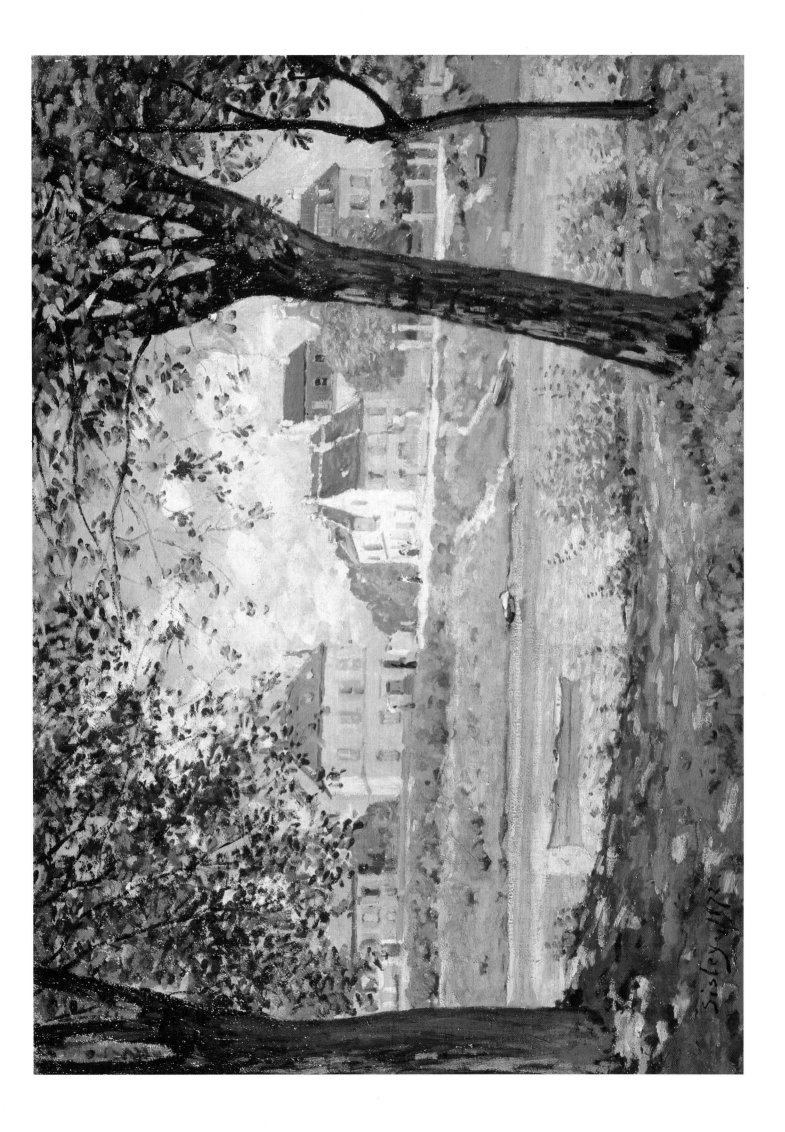

Sentier de la Mi-côte, Louveciennes

1873. Oil on canvas, 38 x 46.5 cm. Musée d'Orsay, Paris

The hillside sentier de la Mi-côte connected Louveciennes with Marly and was a precipitous path high above the Seine valley. Here Sisley appears to show it on an autumn morning, a woman and child descending through the browning trees and bushes of the gardens on either side of the path. The steepness of the hill is indicated by the rush of the bannister and by the wooden 'bridge' up to the roof of the house on the right (which, incidentally, remained in situ until comparatively recently, before being demolished by a landslide). The hilly topography of Louveciennes and its immediate surroundings provided Sisley with abrupt transitions of foreground to background, paths and alleyways turning at right angles below rising slopes of gardens and trees (see Plates 17 and 29).

This is one of Sisley's most beautiful evocations of autumn in its suggestion of morning haze and dampness. At the same time it is one of his most concentrated explorations of spatial complexity. The dark accent of the woman's figure and the fence just below her function as subtle stops in the swift progression from the ground beneath one's feet to the enchanted distance beyond the Seine.

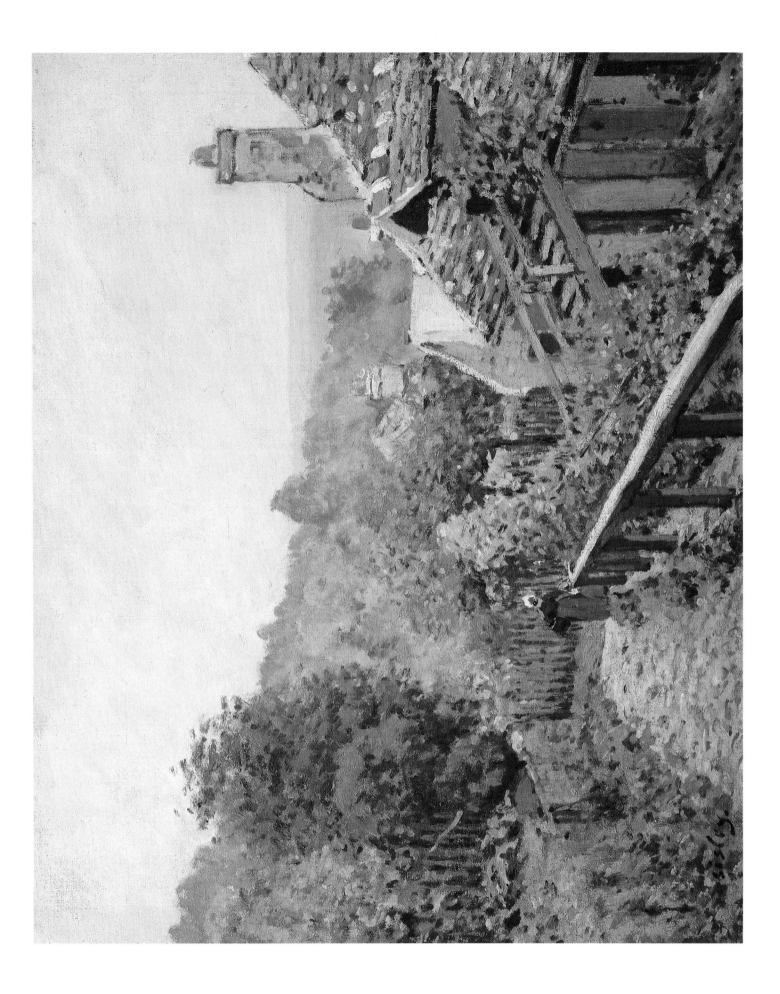

13 Rue de la Princesse, Louveciennes (formerly Street in Ville d'Avray)

1873. Oil on canvas, 55.9 x 47 cm. Private collection

Sisley and his family settled in Voisins, a hamlet attached to Louveciennes, in late 1872 or early 1873, from which time his paintings of the area become numerous. He leased a two-storey house at 2 rue de la Princesse, on a bend of this gently descending street, bordered on one side by the park of the château of Madame du Barry, on the other by cottages, orchards and vegetable gardens. For the present painting, Sisley has stepped from the front-door of his house (at right) and looked up the street towards the château de Voisins at the top.

For a long time this picture was thought to be a view in the village of Ville d'Avray, made famous by Corot's depictions of it in earlier decades. Only recently has an inspection of the street in Voisins revealed Sisley's true motif (little has changed today save for the fact that Sisley's house was demolished c.1978). The wide-open foreground, discreet placing of figures and Sisley's inimitable evocation of the soft sunlight of an autumn afternoon make this one of the most reticent yet perfectly phrased paintings of his early, productive months in Louveciennes. It forms a pair with *Street in Louveciennes* (Plate 18).

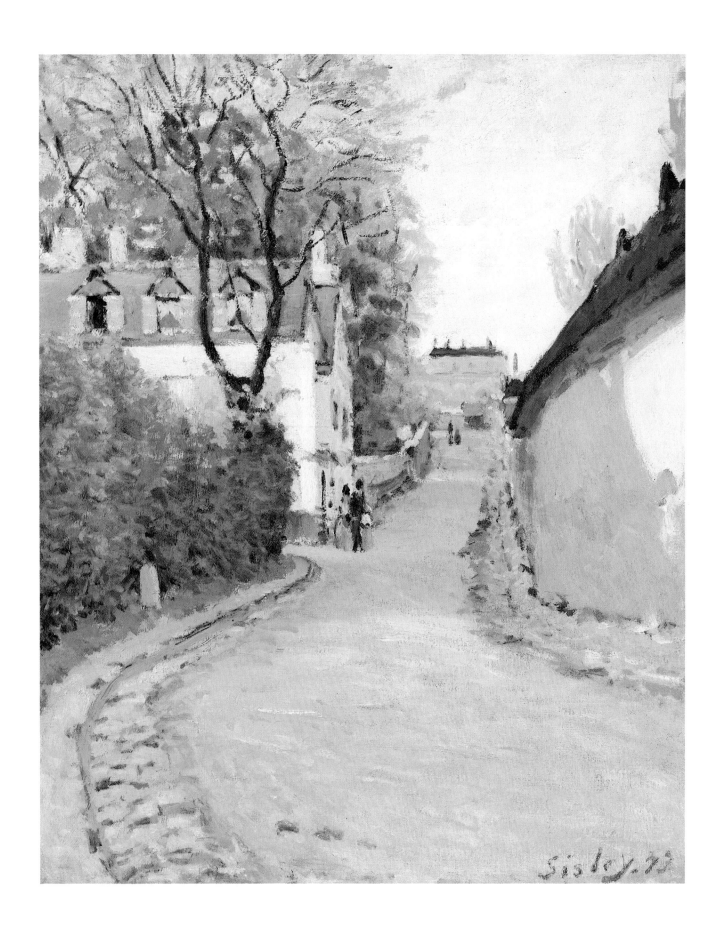

1873. Oil on canvas, 54.5 x 75 cm. Musée d'Orsay, Paris

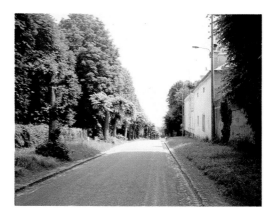

Fig. 16
Chemin de la
Machine,
Louveciennes, 1991

If you walk up the street shown in Plate 13 and turn right at the top you come across the scene shown here and in Plate 15, two views painted in the autumn and winter of 1873-4. Both works exemplify Sisley's content with his immediate surroundings, a lyrical enjoyment of solitude, spatial surprise and an increasing interest in exploring the same subject under different conditions and times of day.

The building to the right is the house of Madame du Barry, favourite of Louis XV, who lived in Louveciennes from 1771 to 1793. Its unusually small windows were designed to minimize the terrible noise of the pumping machine on the Seine which supplied water to the royal gardens at Marly-le-Roi. (The painter Madame Vigée Lebrun, who lived in Louveciennes, wrote that its '*bruit lamentable*' drove her nearly mad.) By the time Sisley moved to the village, many of the elements of its royal and aristocratic past were either in disrepair or had disappeared (see notes to Plates 24 and 25). It was only in recent years that the subject of the present picture was correctly identified (Fig. 16). It had long been in the Louvre's impressionist collection under the title *Chemin à Sèvres*.

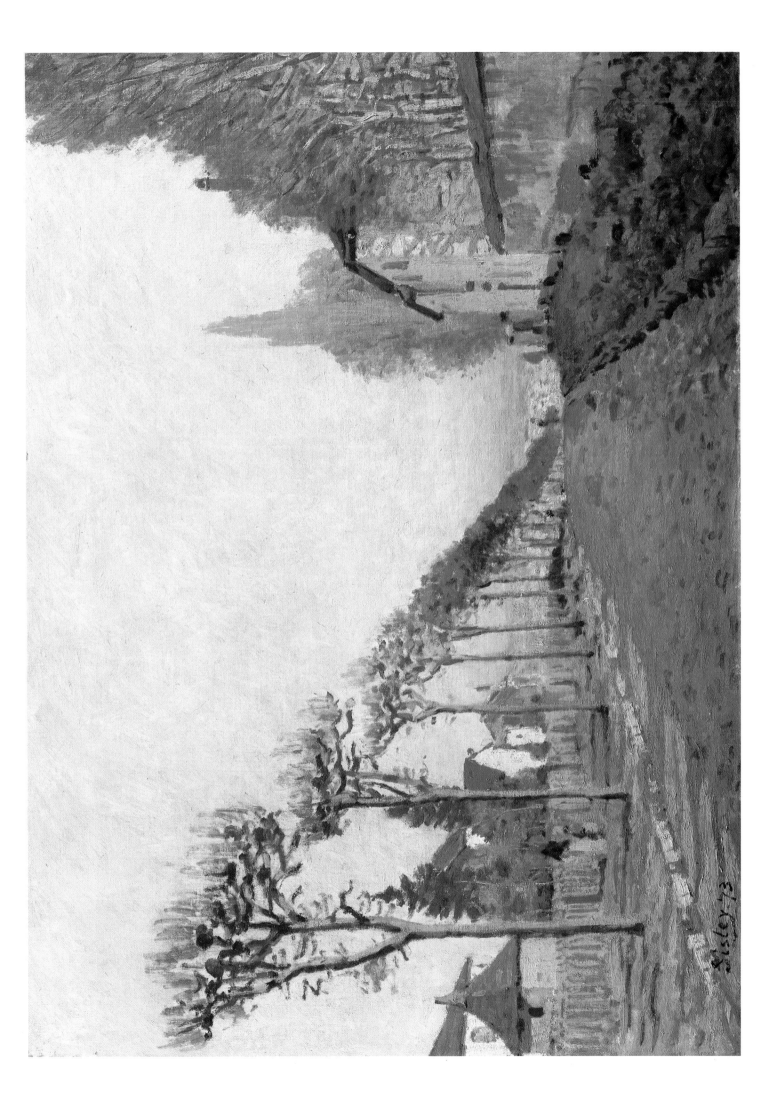

15 Snow on the Road, Louveciennes
(Chemin de la Machine)

1874. Oil on canvas, 38 x 56 cm. Private collection

In this second view of the chemin de la Machine, Sisley has emphasized the starkness of the snow-bound landscape by removing the houses on the left and any vestige of the prospect in the distance. He has moved from the centre of the road to the grass verge to produce a less acute view of Madame du Barry's house but a more dramatic depiction of the line of pollard trees to the left.

Sisley's frequent treatment of the same motif in different seasons and weather was never a programmatic strategy until some of the series paintings of the 1890s. He does not replicate his subject exactly and takes licence, as here, with the elements of the composition. He is more interested in the differences than the similarities.

Sisley's masterly rendering of snow which reached full expression in his celebrated *Snow at Louveciennes* (Plate 29), was encouraged by the severe winters of 1873-4 and 1874-5. After about 1880, he avoided working out of doors in cold weather, the bravado of the 1870s being part cause of his subsequent ill-health (frequent influenza and rheumatism). Later depictions of snow were made from the warmth of indoors (Plates 34 and 41).

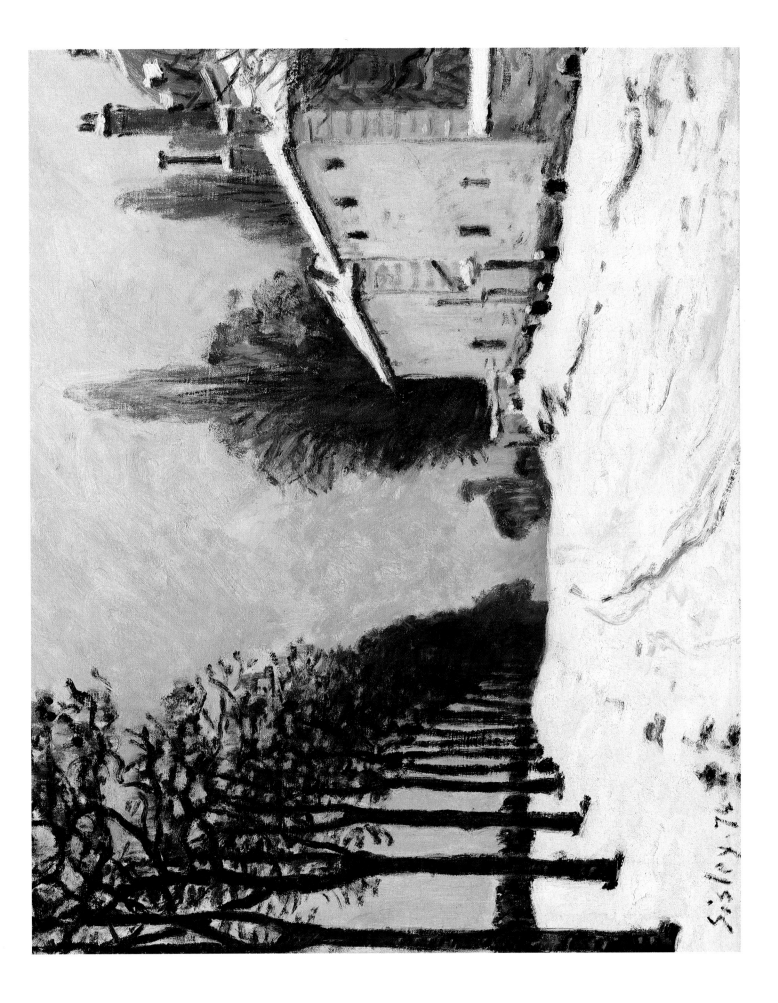

Foggy Morning, Voisins

1874. Oil on canvas, 50.5 x 65 cm. Musée d'Orsay, Paris

There are paintings in Sisley's *oeuvre* showing every kind of weather. He was indomitable in his explorations of its most elusive effects – mist, fog, frost, falling snow, thick snow in sunshine, summer rain, imminent cloudburst, winter cold, hot sun, wind, sunset, damp still days. Only Monet among the Impressionists has a comparable range and betters Sisley in the more dramatic aspects of cliff-top storms or driving urban snow. Sisley is best when attempting more fleeting and delicate effects and *Foggy Morning, Voisins* must rank as one of his most adroit investigations. It was painted in the autumn among the patchwork of market gardens and smallholdings near his house in Voisins. He manages to retain some of the local colour yet invests the whole painting with the grey-blue of morning fog, giving the looming details of the scene an hallucinatory presence.

17 Garden Path in Louveciennes (Chemin de l'Etarché)

1873. Oil on canvas, 64 x 46 cm. Private collection

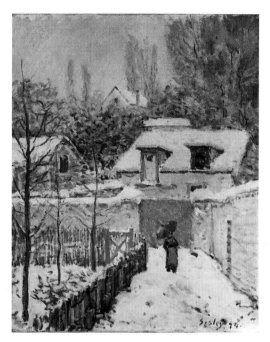

Fig. 17
Snow at
Louveciennes
1874. Oil on canvas,
55.9 x 45.7 cm. Phillips
Collection, Washington,
DC

The balcony of Sisley's house looked across the rue de la Princesse and down the chemin de l'Etarché, a wide path between gardens that soon turned left at a sharp angle and continued towards the edge of the village (see Plate 29). Sisley made it the subject of three of his best known paintings, two of which form a pair – seen on a wet autumn day and in deep winter (Fig. 17).

Several of his favourite compositional devices are brought into play here – the balance of receding verticals and horizontals in a tight but 'natural' framework, the sharply narrowing triangle formed by the fence, the path and the lower edge of the canvas, the blocking of a too-quick spatial recession by the sudden turn of the wall and the brown square of the gate, the carefully placed figure of the woman walking away (and, in Fig. 17, coming towards the viewer). Both paintings exemplify Sisley's exquisite tonal sense – the blue-grey sky in perfect harmony with the richer greens and earth colours in the autumn picture; the balance of whites in the snow painting, its touches of grey and the jade green of the garden gate, giving the whole scene an oriental delicacy, embodied in the woman and her tilted umbrella.

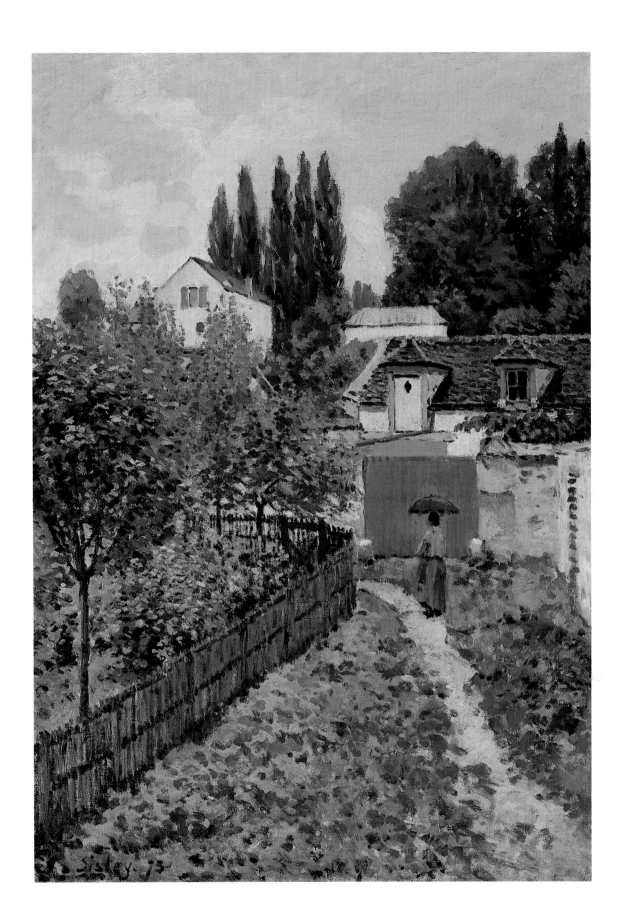

Street in Louveciennes (rue de la Princesse)

c.1874. Oil on canvas, 38 x 54 cm. Phillips Family Collection, USA

A striking feature of Sisley's work, particularly in the early 1870s, is his ability to extract significance from even the most prosaic motif. Here he has simply taken a few steps from his home (at left) and looked down the rue de la Princesse. Nothing spectacular in the way of buildings, an ordinary clump of trees, two figures in the middle distance too small to add any hint of human anecdote; even the early autumn day seems subdued in temper. Yet the painting, in its calm simplicity, encapsulates that note of elegiac withdrawal characteristic of Sisley's mood in so much of his work. The note remains unforced – unlike paintings of similar subjects by the Barbizon artists – and Sisley has nothing to 'say'. It is in works such as this and its 'companion' (Plate 13, in which Sisley, in almost the same spot, has faced the other way and looks up the street rather than down it) extends and refines his response to the ordinary, first adumbrated in his early paintings such as *Lane near a Small Town* (Plate 1) and *Village Street in Marlotte* (Plate 2). In Louveciennes and later in Marly, Sisley became, in Anita Brookner's words 'the greatest painter of suburbs since suburbs evolved'.

19 The Lesson

c.1874. Oil on canvas, 41.3 x 47 cm. Private collection

Fig. 18
Head of a Young Boy
(Pierre Sisley)
c.1877. Pencil,
20.5 x 15.8 cm. Musée
du Louvre, Paris

The Lesson is unique in Sisley's work – a close-up view of figures in an interior. Only three or four other interiors are known and a handful of still lifes in an output of just over 900 paintings, all landscapes. The artist's two children Pierre (b.1867) and Jeanne (b.1869) are seen at their lessons in the family home in Voisins on the edge of Louveciennes (see Plate 18). The casual positioning of the two figures and the swift mosaic of flat, contrasting colour have often been seen as foreshadowing the family interiors of Vuillard and Bonnard 20 years after *The Lesson* was painted. It also relates closely to Monet's two paintings (c.1868-9) of a family at their evening meal, lit from a hanging lamp, and for some time thought to represent the Sisleys at table.

The Lesson was kept by Sisley all his life and, after his death, was eventually sold by his daughter Jeanne in 1907. Images of his family are rare in Sisley's work – there are pencil studies of Pierre (Fig. 18), of the family in the evening (Fig. 19) and Mme Sisley makes a few appearances in some of the landscape paintings. Unlike the families of Pissarro, Monet or Renoir, Sisley's has remained virtually unknown. Jeanne, a painter, died in 1919 and Pierre, a decorator and draughtsman, died in considerable poverty in 1929.

Fig. 19
The Family
c.1880. Pencil, 23 x 31 cm.
Private collection

Bridge at Hampton Court

1874. Oil on canvas, 45.7 x 61 cm. Wallraf-Richartz Museum, Cologne

Sisley's continuing financial struggles and the needs of his young family put travel abroad out of the question. But in 1874, some weeks after the close of the first Impressionist Exhibition, he was invited to England by his friend and patron, the well-known baritone Jean-Baptiste Faure (1830-1914) who had singing engagements in London. It appears that the arrangement involved a gift of a number of paintings in exchange for Sisley's expenses. Beyond the existence of 17 paintings of Hampton Court and its immediate area and one view of the Thames in central London, no details of Sisley's stay are known. Years later he wrote to his friend Adolphe Tavernier that he 'spent several months at Hampton Court, near London, where I did several important studies...it is a charming place'. Faure's enlightened patronage paid off: in the Hampton Court series Sisley achieved, as Kenneth Clark was later to write, 'a perfect moment of Impressionism', paintings probably unmatched for their 'complete naturalism and truth to visual impression, with all its implications of light and tone'.

Sisley's visit to England lasted from about mid-June to early October. From the viewpoint adopted in at least two paintings (including this one) it seems highly likely that Sisley stayed in the Castle Inn whose windows and riverside terrace looked across to Hampton Court Palace (screened by trees) and the substantial Mitre Hotel (seen here at left) on the north bank of the Thames (Fig. 20).

The iron bridge thrusts into the painting, its mass balanced on the right by the great clump of trees echoing the cumulus clouds of the summer sky; two double sculls emerge from under the shadow of the bridge where boats have been propped against the furthest arch. Strollers and sightseers watch from the bank, some of the women holding parasols in the breezy sunshine. The whole design is informed by an overall simplicity – from the minutiae of its motif through the spatial allure of its grandly conceived components. It is among Sisley's great achievements.

Fig. 20
The bridge at
Hampton Court,
1920s

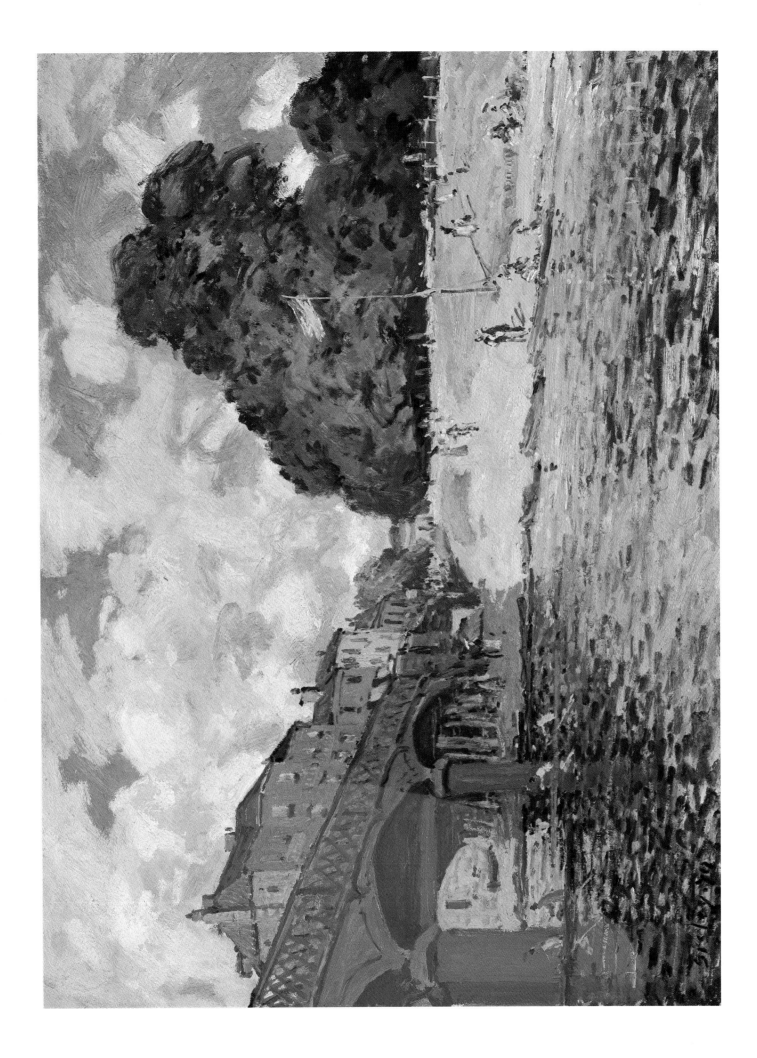

Under the Bridge at Hampton Court

1874. Oil on canvas, 50 x 76 cm. Kunstmuseum, Winterthur

While Sisley was surrounded at Hampton Court by mainly seventeenth-century buildings and by open country along the southern bank of the Thames beyond East Molesey, the bridge at Hampton Court was flagrantly modern. Its five spans of wrought-iron girders supported by painted brick and cast-iron columns had been designed by a well-known engineer, E.T. Murray. The bridge had been opened in 1865, nine years before Sisley's visit; 'ugly' was the word most frequently used to describe it. In style and relative date it was comparable to some of the new Seine bridges painted by the Impressionists in the 1870s in Argenteuil and Chatou.

In Plate 20 Sisley positioned himself to the side of the bridge on the river bank. Here he has gone right under it and produced his most radical and unusual composition. The landscape to the right is the one seen in Plate 20 and, in more detail, in Plate 22; to the left, two sculls are about to pass under the bridge. Here and in the previous picture we see Sisley's new-found mastery in painting water, more closely observed than in earlier river views. He uses a greater variety of colour to suggest broken reflections, his brushwork is more impetuous, the paint dashed on the canvas to catch the full complexity of so fleeting an impression.

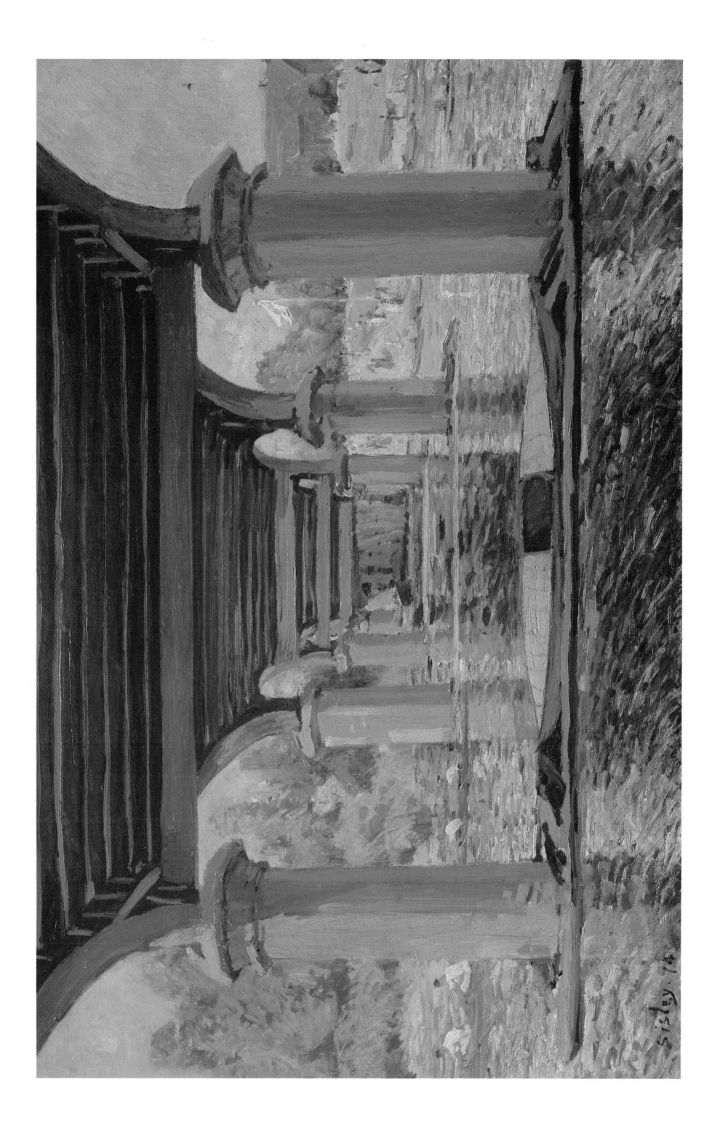

Regatta at Hampton Court

1874. Oil on canvas, 45.5 x 61 cm. Fondation E.G. Bührle Collection, Zurich

Once more Sisley has positioned himself on the riverside veranda of the Castle Inn looking across to Hampton Court Palace, its stable buildings visible on the right. The regatta at Hampton Court was one of the lesser fixtures in the boating calender of the summer season. *Regattas at Molesey* (Fig. 21) shows the newly instituted East Molesey Regatta which took place in the second half of July, after the celebrated Henley Regatta (both events continuing to this day). In Plate 22 it is uncertain what particular part of the fixture is taking place and there appears to be both sculling and pleasure-boating going on in contrast to the crowded professionalism shown in Fig. 21 which seems to show the start of a rowing-eights event. Both paintings are brilliant contributions to early Impressionism in their unusual design, striking contemporary note and synoptic handling of paint. In these and others of the series Sisley is celebrating, in his fastidious way, aspects of up-to-the-minute daily life. But he shies away from the essentially figurative impulse of such subjects found in Renoir on the Seine at La Grenouillère or Gustave Caillebotte in his paintings of yachting and rowing in which he shows a sportsman's interest. In contrast, Sisley remains a spectator on the sidelines primarily engaged with the poetic natural implications of the scene.

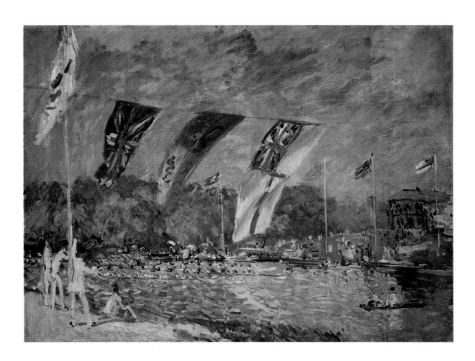

Fig. 21
Regattas at Molesey
1874. Oil on canvas,
66 x 91.5 cm. Musée
d'Orsay, Paris

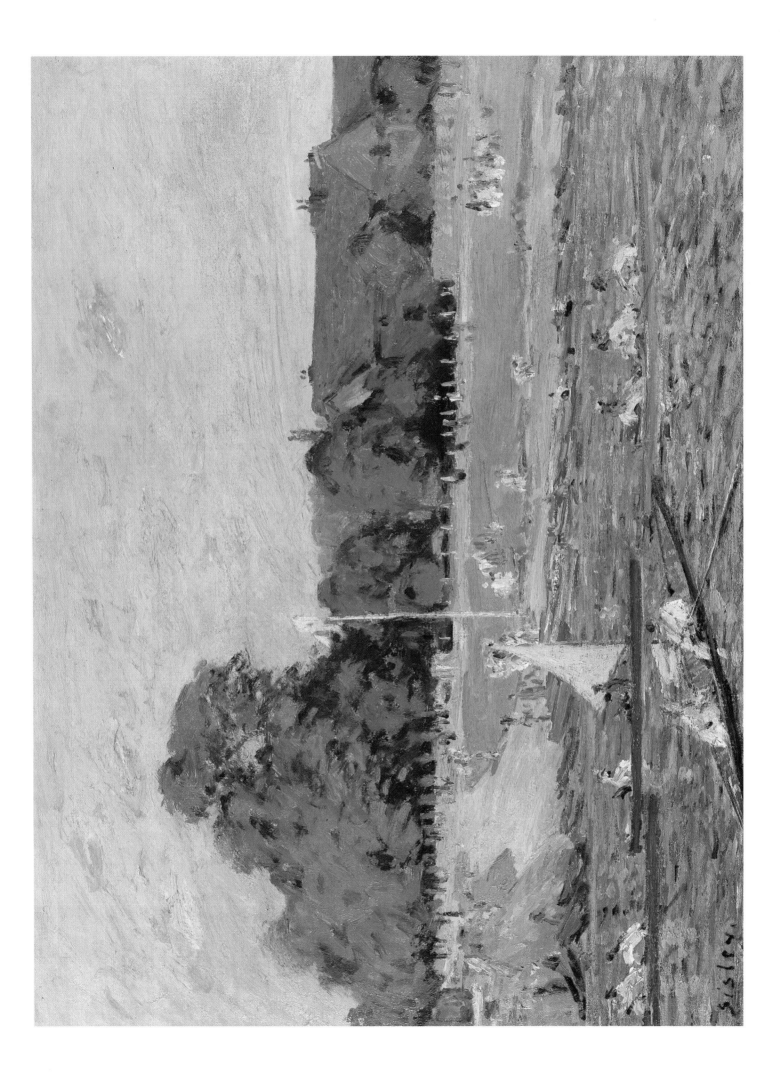

Molesey Weir – Morning

1874. Oil on canvas, 50 x 75 cm. National Gallery of Scotland, Edinburgh

In his months at Hampton Court, Sisley explored all aspects of this small stretch of the Thames – from the quiet reaches towards Hampton village to the busy days of the East Molesey Regatta. Most of the works depict clear or sunny days but this view of the weir, upstream from the bridge, shows a dull, overcast morning. The thick low cloud contrasts with the cool blue of the river and the gushing of the water through the weir. A figure divests himself of his clothes and the two boys, naked, are about to bathe.

Throughout this period Sisley is often at his most convincing when a substantial, man-made structure is viewed within a surrounding fluidity of foliage, water and sky. He situates such features with a breadth of formal control, retaining their weight and solidity and simultaneously allowing them an existence that is dependent on light and air. He holds in suspense the physical permanence of buildings and the transitoriness of their immediate conditions, lightly suggesting all the symbolic overtones of so fragile an equation.

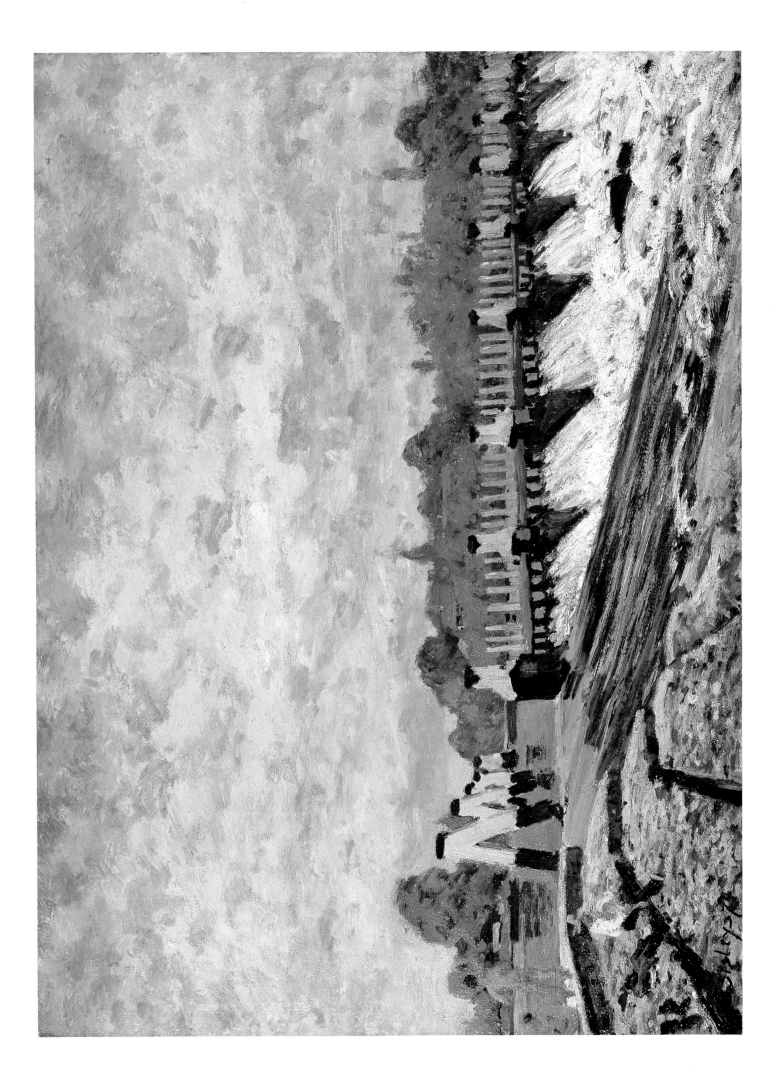

The Machine at Marly

1873. Oil on canvas, 45 x 64.5 cm. Ny Carlsberg Glyptotek, Copenhagen

The 'Machine at Marly' was originally part of the great system of waterworks built for Louis XIV to provide aquatic spectacles at the Château de Marly and at Versailles. The machine pumped water from the Seine and by means of pipes and an aqueduct relayed it to the gardens of Marly. When Sisley came to live in the area, the château had long been demolished, but the waterworks were still a tourist attraction and in 1867 a new machine house had been constructed at Bougival. It appears in many of Sisley's paintings of the river but this one is his most detailed transcription. Alongside his view of the aqueduct (Plate 25) and a number of works showing the watering place at Marly-le-Roi, it forms a record of former royal splendours.

This modestly scaled painting is undoubtedly one of Sisley's masterpieces, daring in composition, perfect in its tonal control. It shows his increasing subtlety in the painting of water, his judicious use of black, his love of repeated features (windows, buttresses, barrage posts) to undermine spatial recession, and his continuing devotion to Corot. It should be remembered, however, that Sisley was here painting a modern, functional building and not, like Corot, the old houses of Volterra or the churches of the Ile-de-France.

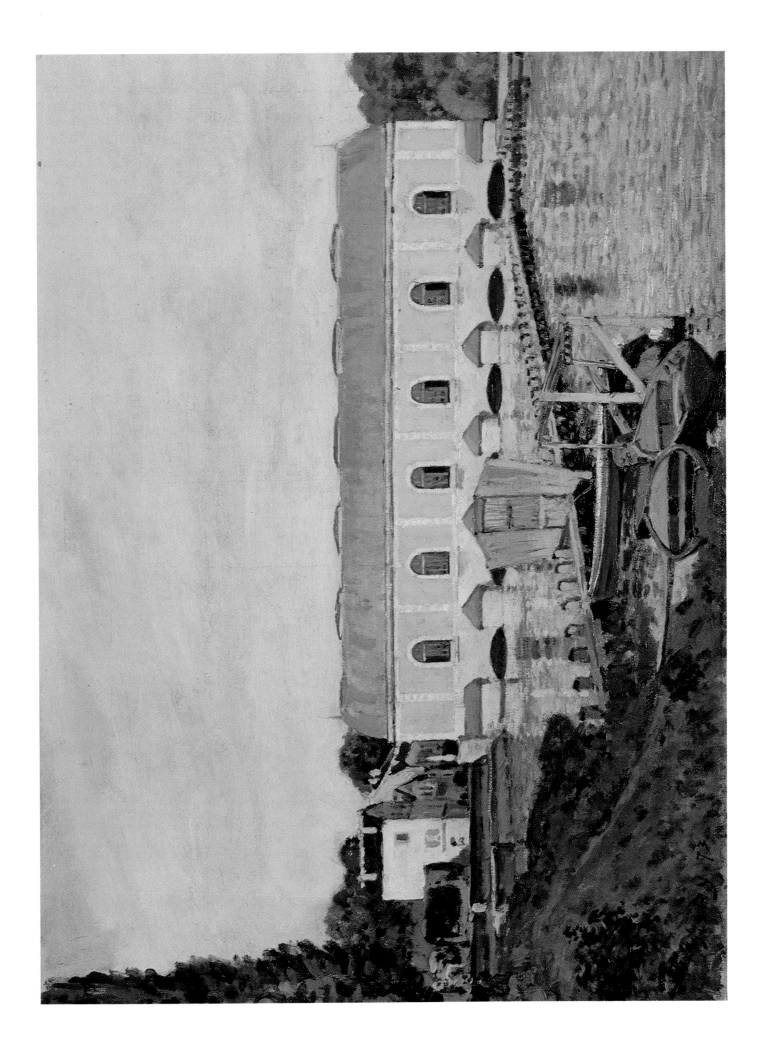

The Aqueduct at Marly

1874. Oil on canvas, 54.3 x 81.3 cm. Toledo Museum of Art, Toledo, OH

This was one of the first paintings Sisley made on his return to Louveciennes from England in the autumn of 1874. The subject served as a monumental reminder, like the 'Machine de Marly' of the days when the area was dominated by court life at the Château de Marly. The aqueduct makes an appearance in innumerable Impressionist paintings (by Renoir, Monet and Pissarro) and had, indeed, been pictured frequently in the past (by Girtin and Turner, for example, earlier in the century). When Sisley painted the structure it had been unused for several years.

Sisley positioned himself on the main road, the route de Versailles, a 10- or 15-minute walk from his home (Fig. 22). His vision of the receding arches against the luminous blue autumn sky eschews all the aqueduct's complex historical associations. A lone cuirassier passes by among the long, evening shadows. Sisley refuses to force the note and presents a view of the structure as though seeing it for the very first time. He simultaneously suggests the physical splendour of the Italianate building as well as its forlorn neglect on the edge of Louveciennes's populous market gardens.

Fig. 22
The Aqueduct at
Marly, 1991

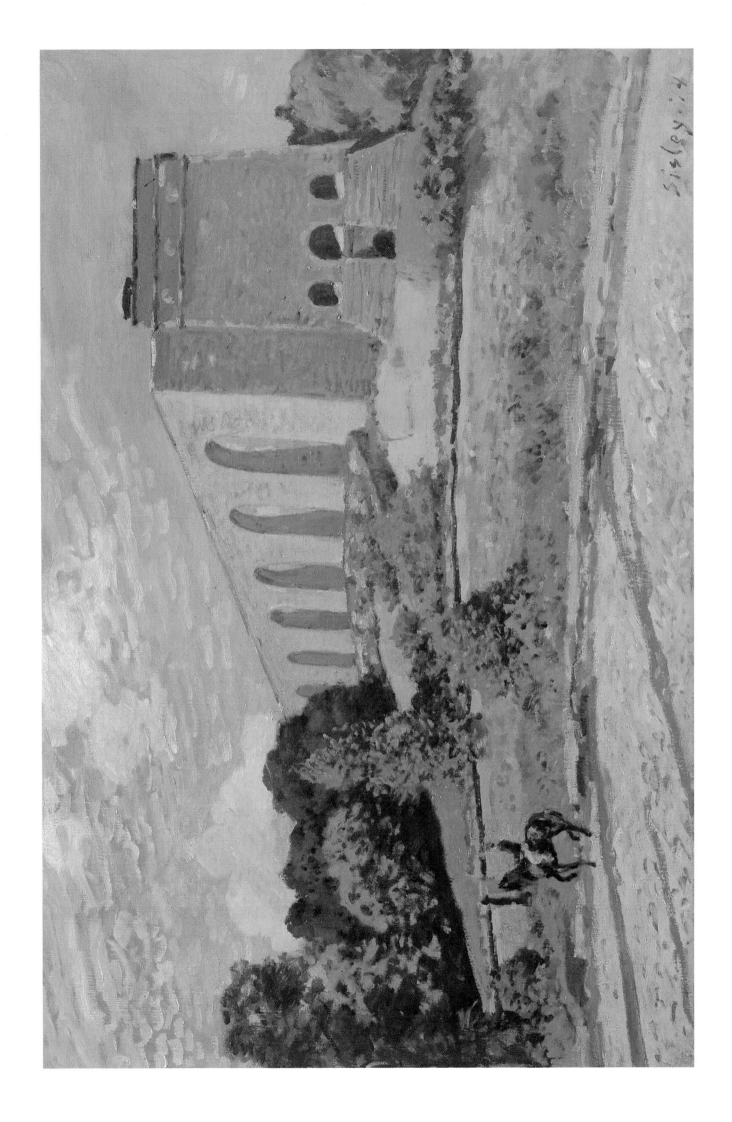

Fête Day at Marly-le-Roi
(formerly The Fourteenth of July at Marly-le-Roi)

1875. Oil on canvas, 54 x 73 cm. Cecil Higgins Art Gallery, Bedford

'Leaving Louveciennes, I made my home for two years at Marly, a stone's throw from Louveciennes, where I made some studies of the watering-place and the Park.' These few words of Sisley's to Adolphe Tavernier summarize his work at Marly-le-Roi, the period of some of his greatest landscapes, culminating in the 1876 series of the flooded Seine at Port-Marly. He seems to have moved house in the winter of 1874-5 and went to live for two years at 2 avenue de l'Abreuvoir. This painting appears to have been made from an upper window of his house on a wet summer's day, looking towards the 'Abreuvoir' or watering place. This was another if more modest reminder of the cascade and fountains of the Parc de Marly (the Château looked down towards the 'Abreuvoir' and surrounding houses from its position on the green slope seen here between the trees). The 'Abreuvoir' collected water from the gardens and served the village as well as being a watering place for horses. Sisley painted it from almost every angle and in all weathers, the expanse of water sometimes central to the composition and sometimes, as here, peripheral, screened by the pollard trees that surrounded it.

This painting was long known as *The Fourteenth of July at Marly-le-Roi*. However, *le quatorze juillet* was not instituted as a national fête day until 1881. More than likely it shows the festival of St Pierre celebrated in many *communes* in the first week of August. Republican flags droop in the downpour above passers-by with umbrellas. It is inconceivable that Sisley would have made any political point in his paintings; they remain aloof and 'pure'. Even so, the implications of the scene shown in *Fête Day* could hardly have been lost on him (English though he was), as he contemplated the ghostly swathe between the distant trees and remembered the extravagance of 'les Marlys' of Louis XIV nearly two centuries before.

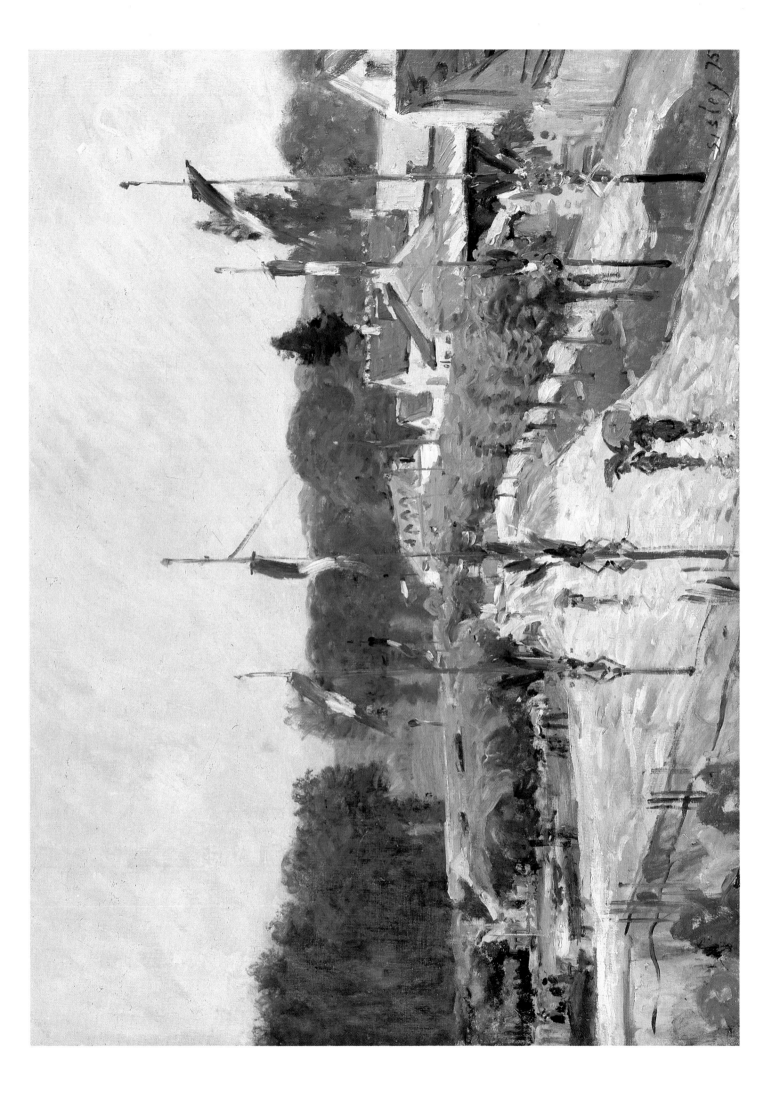

View of Marly-le-Roi – Sunshine (formerly View of St-Cloud)

1876. Oil on canvas, 54.2 x 73.2 cm. Art Gallery of Ontario, Toronto

For this beautiful evocation of a tranquil summer's morning, Sisley has gone into the Parc de Marly. To the right, below a low parapet, is the 'Abreuvoir'; in the centre, the village of Marly-le-Roi, surmounted by the spire of its twelfth-century church, clusters tightly down the hillside. The bright colours of its tiled roofs are thrown into relief by the dark massing of the trees to the left and balanced by the shadowed grass along the lower edge of the canvas. When Monet, for example, chooses a similar subject (Fig. 23), a woman and children are gathering flowers in the foreground adding a note of seductive contemporaneity. In Sisley's painting, no suggestion of sound or movement interrupts his idyllic vision.

Fig. 23
Claude Monet
Poppies in a Field
near Vetheuil
1879. Oil on canvas,
70 x 90 cm. Fondation
E.G. Bührle Collection,
Zurich

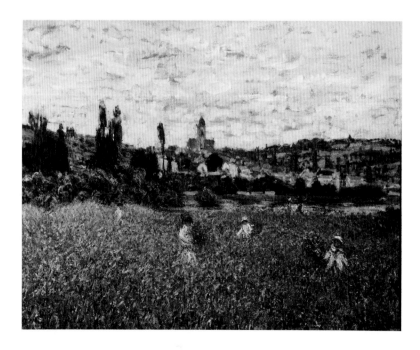

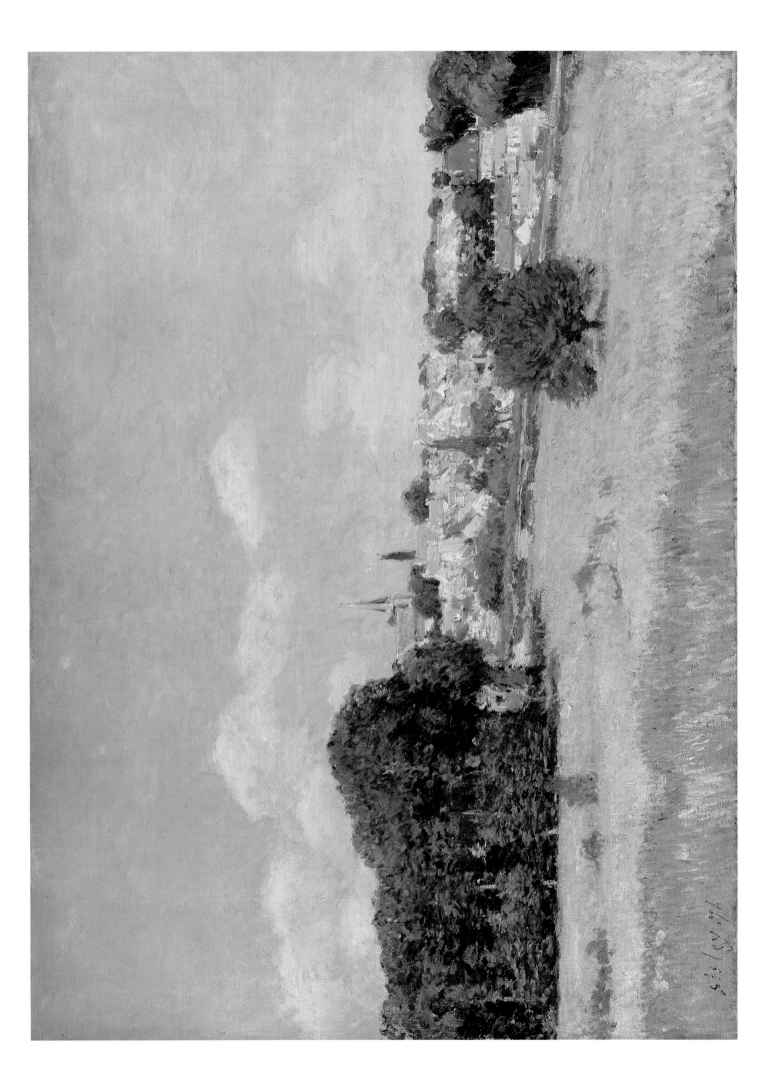

Sand on the Quayside, Port Marly

1875. Oil on canvas, 46 x 65 cm. Private collection

For most of his career Sisley was more interested in depicting the working life of the rivers by which he lived rather than their role as providers of pleasure (the interlude at Hampton Court was an exception). Scenes of yachting and weekend bathing, as painted by Renoir, Monet, Manet and Caillebotte are mostly absent from his work. When he shows, for example, the fashionable bathing place of La Grenouillère it is closed for the season. But he delighted in all aspects of riverside activity – fuelling stops and wharfs, barges and dredgers, boat-building yards and women washing clothes in the bankside *lavoirs*. Here he shows the small port known as Port-Marly, a 15-minute walk downhill from his home in Marly-le-Roi. It was a view he painted on several occasions (eg *Sand Heaps*, 1875, Art Institute of Chicago, and a number of paintings of the *lavoir*, built out into the river). In order to control the flow of the Seine, here broken by successive mid-stream islands, sand was deposited on the riverbed and huge piles dotted the bank, attended by men in characteristic flat-bottomed boats. In the background are the inns and houses of the rue de Paris, the subject, in very different conditions, of Sisley's best-known paintings (Plates 30-32).

Snow at Louveciennes

1875. Oil on canvas, 61 x 50.5 cm. Musée d'Orsay, Paris

It might be said of the Impressionists – Monet, Pissarro, Sisley – that they added the motif of the landscape under snow to the tradition of European painting. Of course, it had appeared before, particularly in Dutch seventeenth-century art and earlier in Bruegel, but its occurrence was fitful. The Barbizon painters in the early to mid-nineteenth century began to include snow scenes among their repertoire of seasonal effects but, of the Impressionists' immediate forebears, Courbet was the artist with the most consistent interest in the subject.

Sisley painted snow in all its permutations (only rivalled in this respect by Monet) – from the tentative first fall (Plate 5) to the heavy, silencing blanket of deep winter (Fig. 24). Where Monet is the master of the *débâcle*, of the gliding ice-floe and desolated landscape, Sisley shows villages and gardens wrapped in inviolable silence, branches laden, skies thick with a further fall (Plates 15 and 34; Fig. 29). His perfect sense of tone is nowhere better seen than in some of these grey-blues, touches of lemon and malachite green against a variety of whites. The tracery of branches, lone figures, receding walls and fences give to such scenes their Oriental delicacy.

This painting shows another section of the chemin de l'Etarché (Plate 17 and Fig. 17). Until very recently the date on the picture was read as 1878 (when Sisley had already left Louveciennes). But a recent inspection shows it as 1875 thus returning it to the great period of his snow scenes.

Fig. 24
Snow-scene with
Huntsman
1873. Oil on canvas, 50 x
65 cm. Present
whereabouts unknown

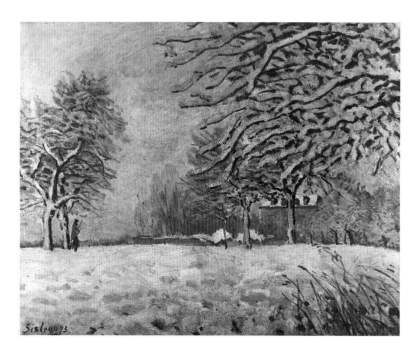

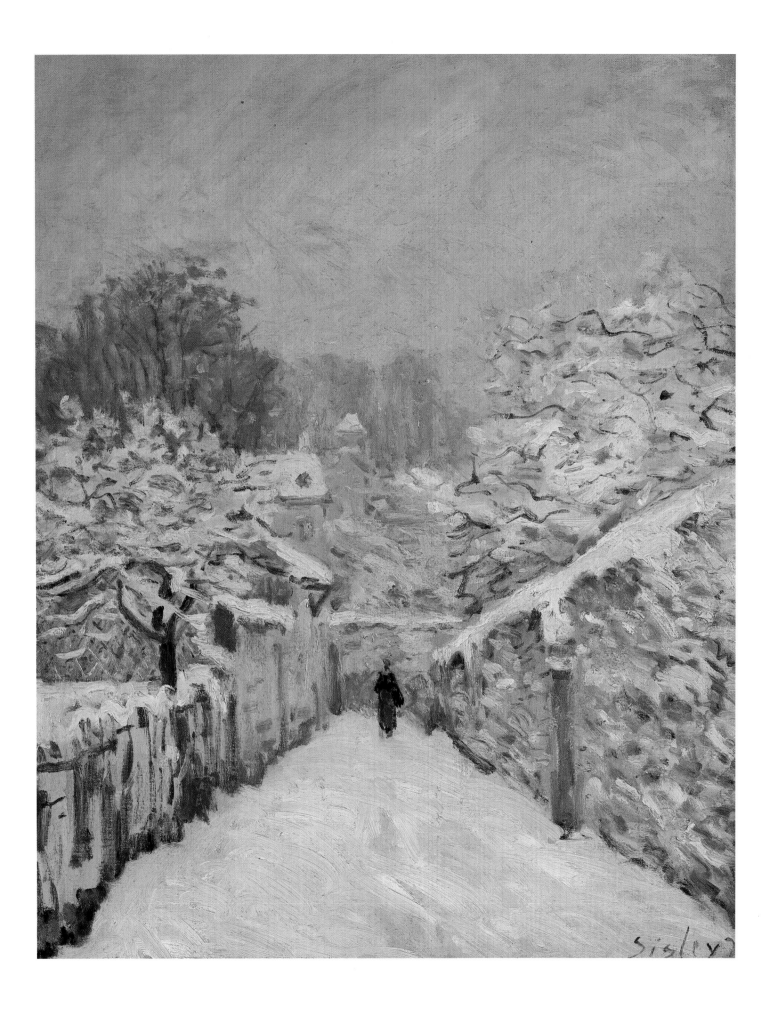

Flood at Port-Marly

1876. Oil on canvas, 50 x 61 cm. Musée des Beaux-Arts, Rouen

Fig. 25
Quai de Paris, Port-
Marly, 1991

This and the two following plates belong to Sisley's most famous group of works, his unsurpassed views of the quayside at Port-Marly under floodwater, made in March 1876. He had painted floods on previous occasions, notably the *Ferry to the Ile-de-la-Loge – Flood* (Fig. 26) and *Flood at Port-Marly* (National Gallery of Art, Washington DC) both of 1872. The latter depicts the same view as Plate 30, showing Sisley's willingness to return to a motif if he felt there was more to extract from its elements.

The main road from Marly-le-Roi curves downhill to Port-Marly and, becoming the rue Jean-Jaurès, runs at right-angles into the riverside quai de Paris. Where it emerges near the river, on one side is an inn and wine-shop, A St-Nicolas, and on the other the Lion d'Or. Both these establishments still exist as does the row of trees separating the road from the Seine (Fig. 25). Here, with his back to the Lion d'Or, Sisley pitched his easel, the floodwater lapping his feet, to paint the present work, one of the earliest in the series of seven (another version is in the Musée d'Orsay).

The group of Port-Marly paintings shows the flood at various moments of its progress – from its full limit (Plate 30) to later recession (Plate 31) and gradual diminution (Plate 32). In the first, the sky is still heavy with rain and the human predicament is suggested by the planks raised on barrels around the inn; in the second, these have been removed and Sisley is able to go a little nearer to his subject; the sky is clearing and the trees are touched with spring. In the third, normality is returning and a coach has resumed its quayside route. There is an almost film-like sequence to the series, the changes in the subject motivated by a perceptible progression in time rather than by purely aesthetic considerations.

Although human drama is present, Sisley did not force a response to the scene but favours an almost Olympian detachment. In their fusion of sky, water, reflections, in their equation of the human and the natural, Sisley achieves a grandeur that he rarely attained again.

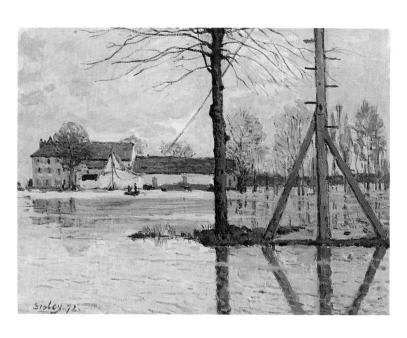

Fig. 26
Ferry to the Ile-de-la-
Loge – Flood
1872. Oil on canvas,
46 x 61 cm. Ny Carlsberg-
Glyptotek, Copenhagen

Boat in the Flood at Port-Marly

1876. Oil on canvas, 50.5 x 61 cm. Musée d'Orsay, Paris

See note to Plate 30. This was one of the two paintings of the floods at Port-Marly bequeathed to the Louvre in 1908 by the collector Comte Isaac de Camondo. The other work, the version of Plate 30 alluded to in the note to that picture, was purchased by Camondo a year after Sisley's death for the large sum of 43,000 francs, an event that heralded the artist's posthumous fame and the rapid increase in the value of his works.

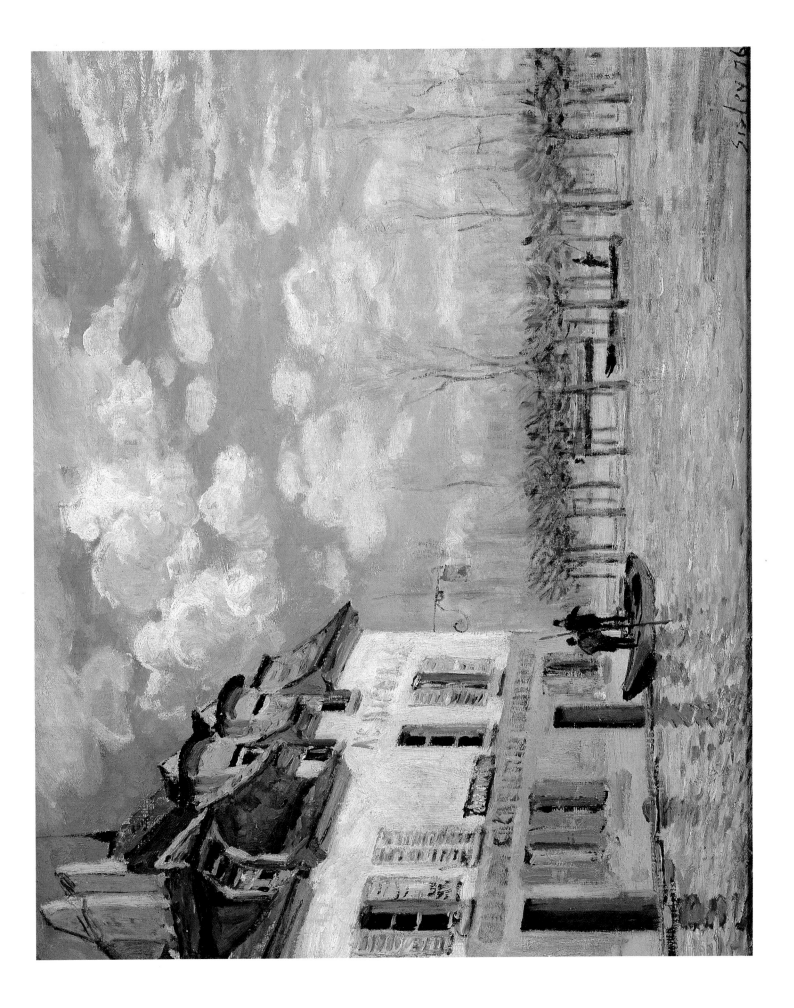

Flood at Port-Marly

1876. Oil on canvas, 50 x 61 cm. Thyssen-Bornemisza Collection, Madrid

For this painting's place in Sisley's sequence of works showing the floods at Port-Marly see the note to Plate 30. It appears to have come at the end of the series, as the floods abated. It was swiftly painted, no doubt in front of the motif itself, the quickly changing scene and rapid movement in the clouds mirrored in Sisley's dashing and synoptic handling of paint.

The painting was almost certainly shown in the third Impressionist Exhibition in Paris (April 1877) and commended for its 'charming poetry' by Georges Rivière in a review in *L'Impressionniste*. Sisley generally escaped the severe criticisms doled out to his colleagues such as Monet or Pissarro; but praise, too, was hard to come by save in the small circle of his admirers such as the poet Mallarmé and collectors such as Georges Charpentier and Jean-Baptiste Faure.

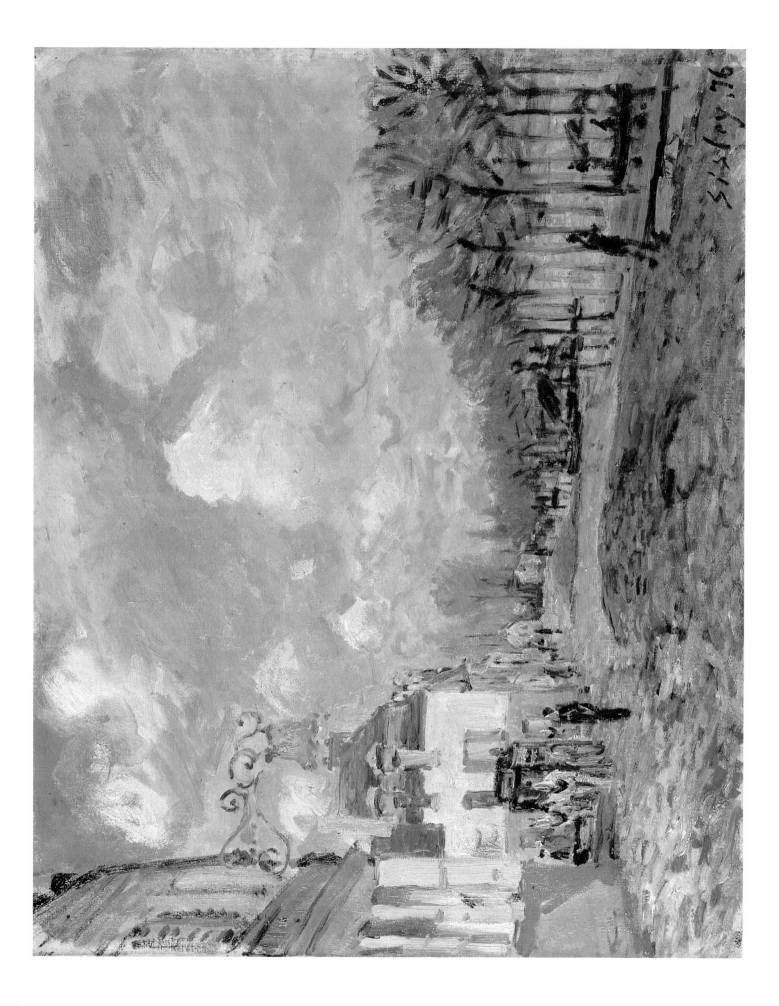

Station at Sèvres

c.1879. Oil on canvas, 15 x 22 cm. Private collection

Sisley finally left the area of Louveciennes and Marly in 1877 (perhaps in the late spring) and settled in Sèvres on the Seine nearer to Paris. Depictions of rural life and the quieter reaches of the river were virtually abandoned in this transitional period (1877-80) for the busier section of the Seine as it approaches the capital. He painted the bridge at Sèvres many times, as well as its new station; barges at Billaincourt; the Point-du-Jour and the new Palais du Trocadéro (the nearest he came to working in Paris); telegraph poles at Ville d'Avray; the station and new road at Bas-Meudon and the impressive viaduct at Auteuil (Fig. 27). Puffs of steam and smoke from trains (seen here behind the station building), from boats and factory chimneys echo the grander cloud formations in the sky. Sisley shows the small towns and villages once depicted by Corot, now in the process of being engulfed by Paris; fields on one side of the railway line (here passengers go to and from the station through mown pasture), new villas on the other.

This period at Sèvres, which found Sisley in severe financial hardship, witnessed a misguided attempt at increasing the range of his subject matter away from pure landscape and an increasing complexity in the handling of paint. His brushwork becomes more flickering and agitated; his range of colour either subdued and gloomy or pitched high towards acidic greens and sharp blues and pinks. Although there were still notable successes, the work from the years in Sèvres often falters. By the end of 1879 Sisley realized that further change was necessary and his thoughts turned to the Forest of Fontainebleau, an area he knew well but where he had not painted since 1868.

Fig. 27
Viaduct at Auteuil
1878. Oil on canvas, 46 x 61 cm. Present whereabouts unknown

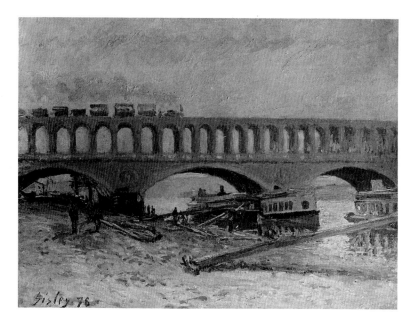

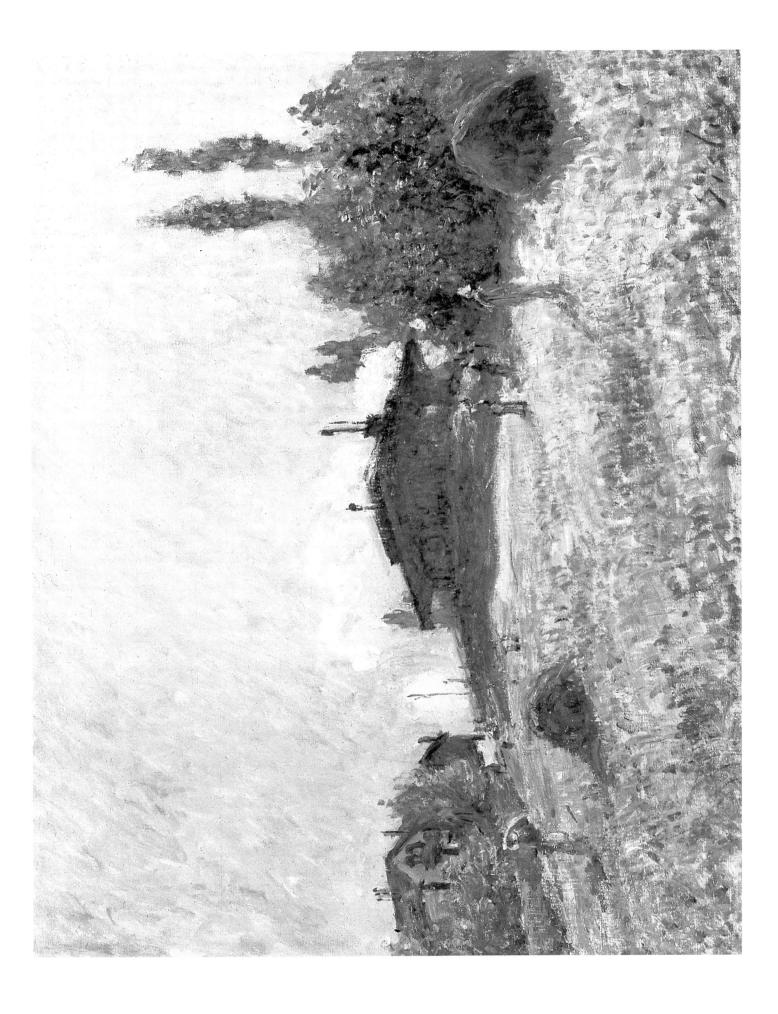

Snowy Weather at Veneux-Nadon

c.1880. Oil on canvas, 55 x 74 cm. Musée d'Orsay, Paris

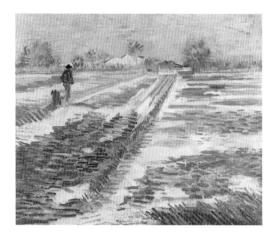

Fig. 28
Vincent van Gogh
Landscape under
Snow (Arles)
1888. Oil on canvas,
40.5 x 48.2 cm. Solomon
R. Guggenheim Museum,
New York

Early in 1880 Sisley and his family moved to the village of Veneux-Nadon near Moret-sur-Loing, 75 kilometres from Paris on the edge of the Forest of Fontainebleau. Although connected to the capital by rail (with its station at Les Sablons, next to Veneux-Nadon), Moret was definitely in the provinces and hardly touched by the social and economic revolutions of the nineteenth century. It was in various houses in and around this picturesque town that Sisley spent the rest of his life.

On arrival, he immediately resumed work and painted the village street, seen from the windows of his home, under snow, a bleak intro-duction to his newly found terrain. Streaks of green and lemon in the late afternoon sky foil the cool pink and ochre tones of the foreground with its trudging passer-by. (Vincent Van Gogh, who admired Sisley's work, may well have remembered paintings such as this when he arrived in Arles eight years later and painted the city's outskirts under snow; Fig. 28.) Another view (Fig. 29), from the following year, shows the well and wall of Sisley's garden, the railway line, at left, Moret in the distance, and people passing, a further demonstration of the artist's inspired transformation of Japanese prints.

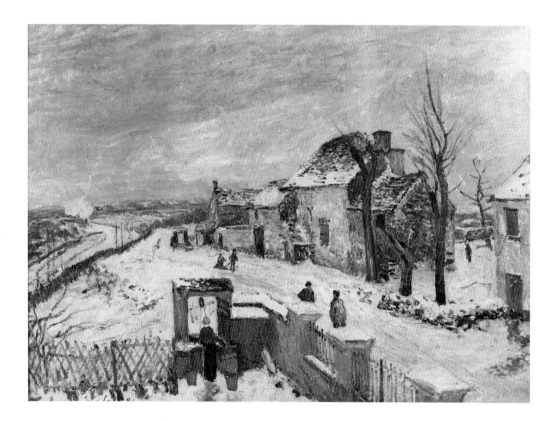

Fig. 29
Winter at Veneux-
Nadon
1881. Oil on canvas,
50 x 65 cm. Private
collection

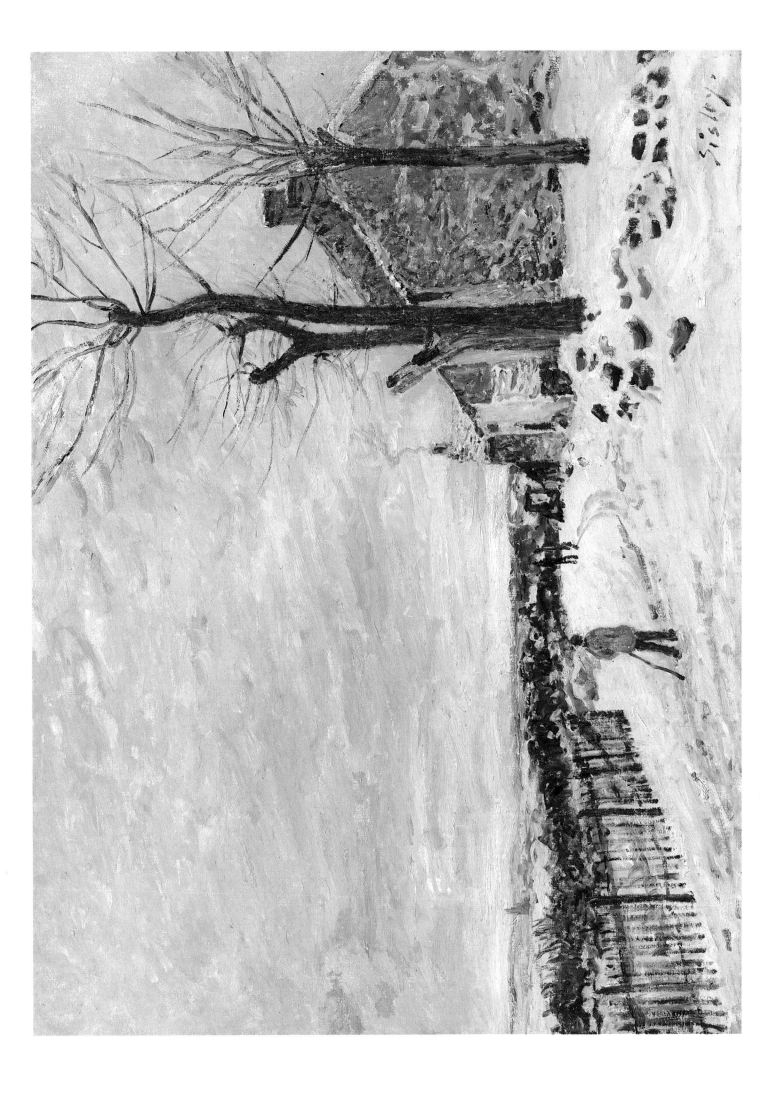

1881. Oil on canvas, 54 x 72 cm. Museum Boymans-van Beuningen, Rotterdam

One of the areas Sisley first discovered and to which he returned over the following three years was the Seine-side path from Veneux-Nadon to the village of By (see map, Fig. 30). The Seine is broad here and the villages of By and Thoméry are high up on the rocky cliff above; orchards and vineyards slope down to the tree-lined banks of the river. Sisley's delight in his new surroundings is seen at its freshest in several spring-time views (see Plate 36). All have a vitality of handling and an exuberance of colour and subject that strike a refreshing note after the last, ennervated paintings made at Sèvres. The startling figure of a girl – almost certainly Jeanne his daughter, then aged 12 – reaching up to the trees, and the smaller figures in the middle of a woman and child, establish the depth of recession Sisley is attempting as well as the height from which he surveys the Seine seen through the trees at the left. This sequence of riverside paintings amplifies and brings further subtlety to Sisley's earlier spatial discoveries made by the Seine at Port-Marly and Bougival in the mid-1870s.

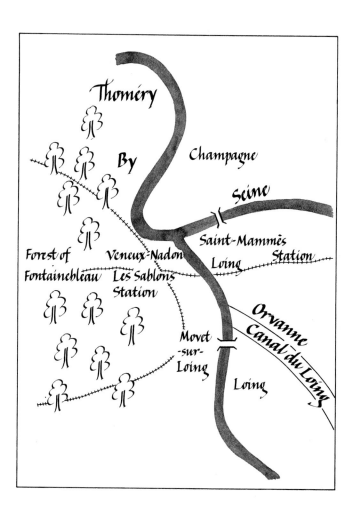

Fig. 30
Map of Moret-sur-Loing and its environs

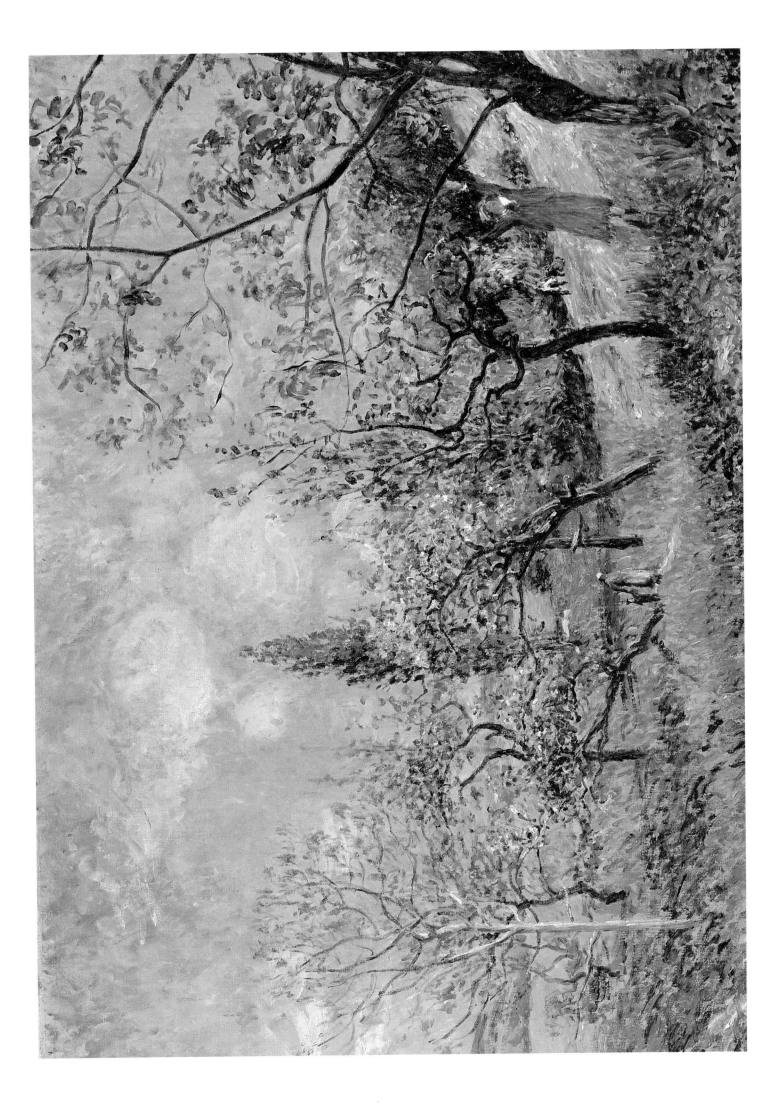

c.1881. Oil on canvas, 54 x 73 cm. National Gallery, London

The spatial subtleties noted in the previous work are fully in evidence in this lushly painted view of the same stretch of river. Here Sisley looks north, the village of By above him to the left, that of Champagne across the river at right. The composition is not dissimilar to the very early *Lane near a Small Town* (Plate 1) though seen in reverse, with the landscape opening up to the far distance on the right rather than the left. The intruding branches along the right edge of the canvas, however, help to give a more fluent suggestion of the space in which Sisley – and the viewer – is situated. And the standing girl – again, undoubtedly Jeanne Sisley (she wears the same dress and hat as in the previous picture) – both anchors our attention in the foreground and articulates the recession of the path behind her.

A similar painting, again including Jeanne Sisley, depicting this wooded path (the chemin des Fontaines) in morning light, rather than the softer afternoon light depicted here, is in the Stirling and Francine Clark Institute, Williamstown.

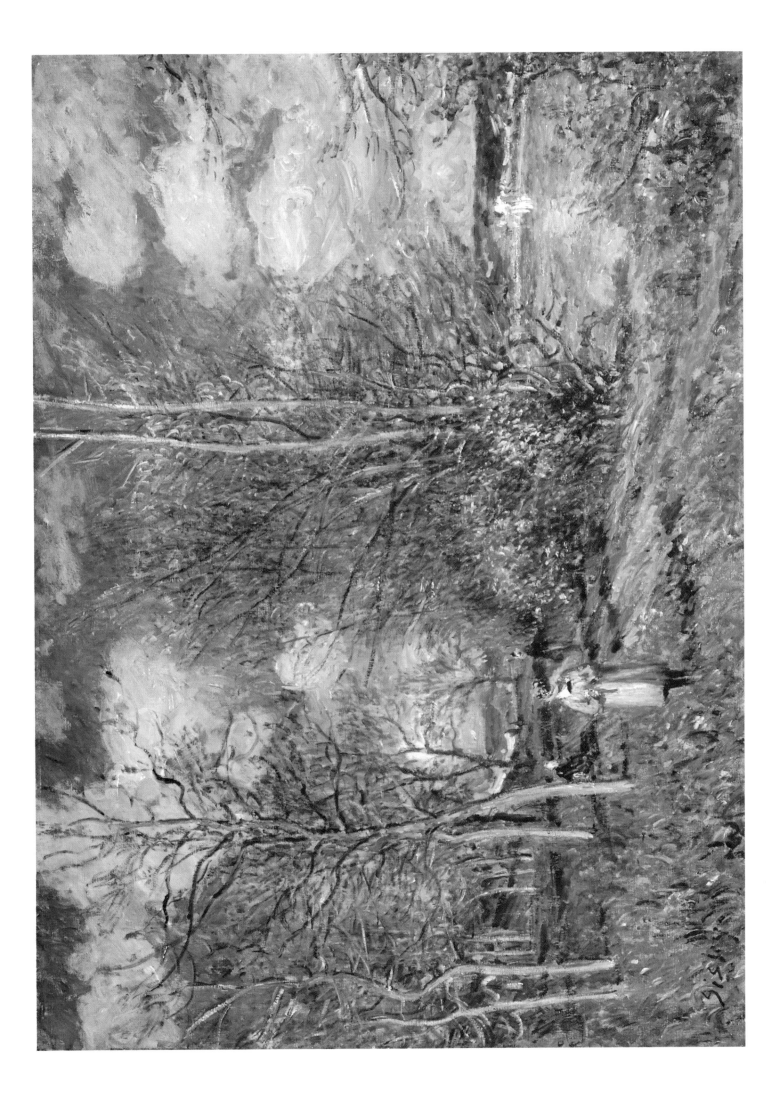

c.1883. Oil on canvas, 38 x 55 cm. Musée départementale de l'Oise, Beauvais

Fig. 31
The site of Matrat's
boatyard (left
foreground) at Moret-
sur-Loing, 1991

As the 1880s progressed, Sisley investigated all the possibilities offered by the area around Moret-sur-Loing. He was an indefatigable explorer of the banks of the Loing itself and the Canal du Loing (Plate 43), both of which merge and flow into the Seine at St-Mammès (Plate 38), the little port north of Moret; he worked in the fields on the edge of the Forest of Fontainebleau and the smallholdings around Moret itself, affording distant views of its dominant church tower. One of his favourite viewpoints was from a wooded spit of land made by the Canal's merger with the Loing. It was along the river bank that Matrat's boatyard was situated. From here the old town of Moret, capped by its church and fronted by the mills clustered along its bridge, provided Sisley with the type of panoramic yet intimate image that links him with the landscapists of seventeenth-century Holland. Tall poplars to the left balance the varied horizontals formed by the far bank of the river and its lines of trees. Here, Sisley has taken a wider view affording a more oblique perspective of the trees to the left and obscuring much of the river by a boat at the right. The foliage of the trees is given in Sisley's most brisk, dense manner, the brushstrokes taking the form of overlapping commas with dashes of white to evoke movement in sunlight.

Vestiges of Matrat's boatyard remain today on this now more intractable stretch of the Loing (Fig. 31).

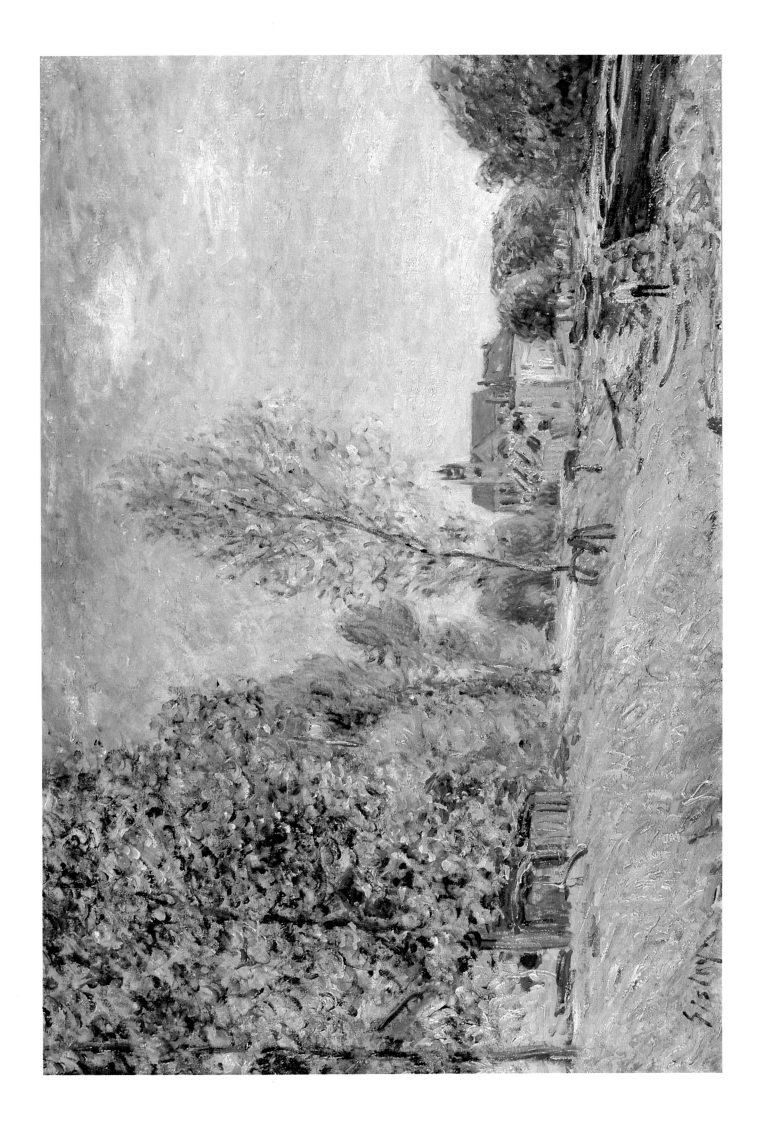

The Canal du Loing at St-Mammès

1885. Oil on canvas, 74.9 x 93.3 cm. Philadelphia Museum of Art, Philadelphia, PA

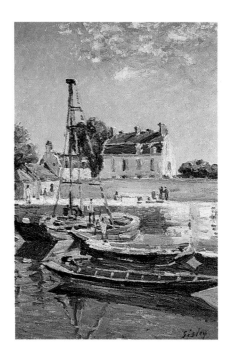

Fig. 32
Boats
c.1885. Oil on canvas,
55 x 38 cm. Private
collection

Of all the subjects painted by Sisley in the 1880s, the one to which he returned most often was the last stretch of the Loing as it flows into the Seine at St-Mammès (see map, Fig. 30). Sisley invariably positioned himself on the left bank of the Loing north of Moret looking over to the houses on the right bank, the most prominent of which is the custom-house set back from the towing path behind a long wall (the violet horizontal in this sunlit view). There are nearly 50 paintings looking up or down the river – towards the Seine, as here, and back towards Moret under a spectacular white viaduct.

Sometimes Sisley depicts this expanse of river as deserted, even forlorn, shimmering under a hot afternoon sky. At others it is busy with barges (*péniches*) gathered at the weir or under repair (Fig. 32), breaking the reflections in the water (as the ducks do in the foreground of this canvas) to give animation in contrast to the sky or, as here, in unison with its broken cloud.

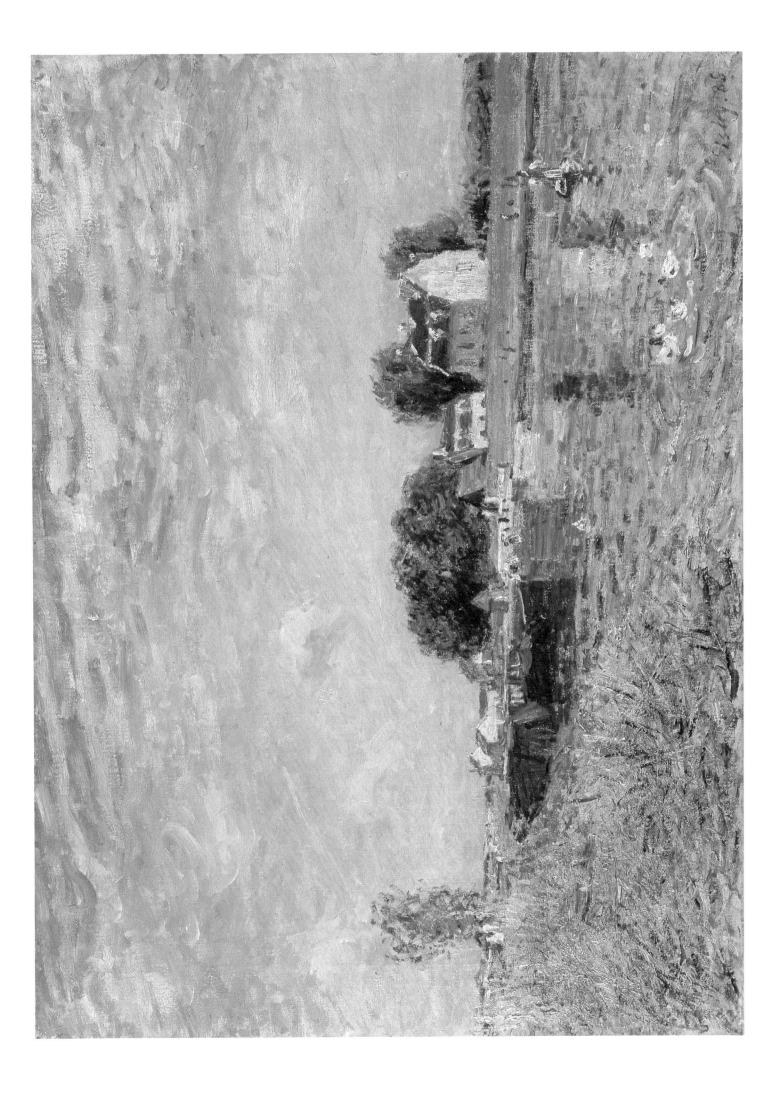

1884. Oil on canvas, 73.5 x 93 cm. Musée d'Orsay, Paris

Fig. 33
The courtyard at 41
rue Vieux-Relais St-
Mammès, 1991

On a few occasions in the 1880s, Sisley varied his output of landscapes with views of houses and farmyards. He was still in the open air and still engaged by the relation of sky to land but the presence of buildings rather than passages of fields, water and trees returns him to the complex overlapping of walls and windows at a variety of angles that appears in much earlier works (compare this painting with, for example, Plate 6).

Here, Sisley has entered the courtyard of an ancient house fronting the rue Vieux-Relais which runs alongside the Seine at St-Mammès (glimpsed through the arch in the centre of the picture). The scene, though much altered, is recognizable today (Fig. 33). A drawing made by Sisley in a notebook records that the women are plaiting rushes ('*tresseuses de jonc*') and that he sold the work to his friend, the painter Gustave Caillebotte, for 500 francs.

Such is Sisley's success in this and a few other views of domestic village life (eg *Courtyard at Les Sablons*, Aberdeen Art Gallery, or the earlier *Forge at Marly*, Musée d'Orsay) that it is curious – and regrettable – that he did not attempt them more often.

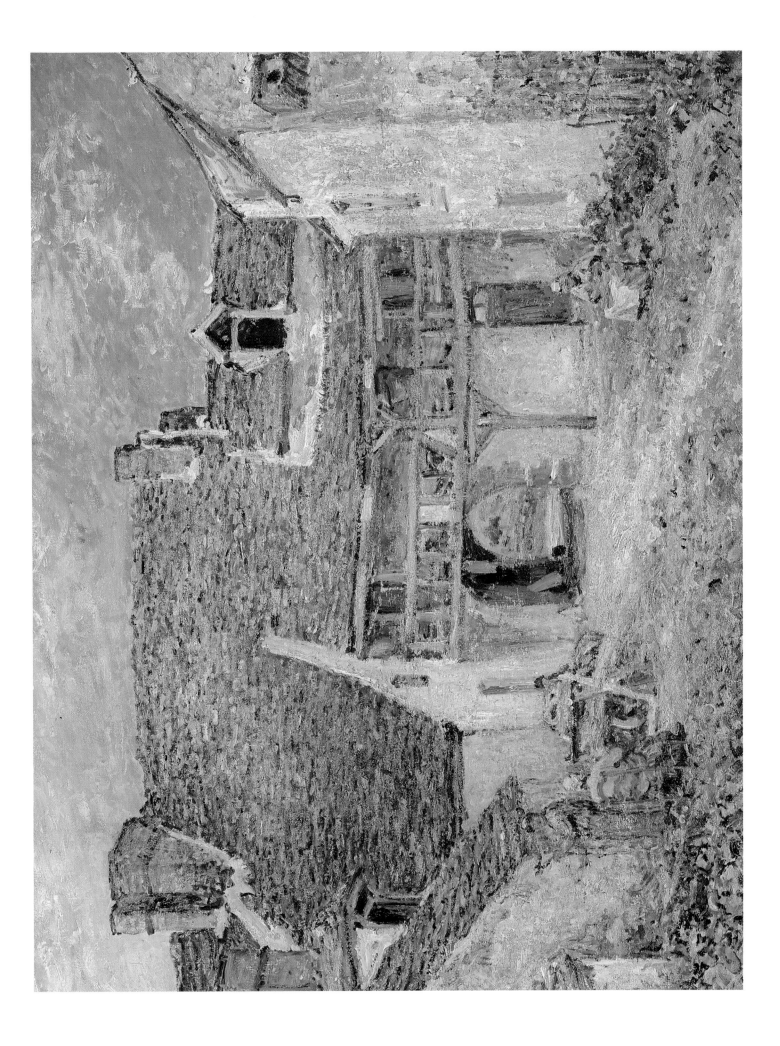

Provencher's Mill at Moret

1883. Oil on canvas, 54 x 73 cm. Museum Boymans-van Beuningen, Rotterdam

The low, arched stone bridge over the Loing at Moret was the setting for two or three water mills for flour and tanning, one of which, Provencher's Mill, was connected to the bridge by a wooden walkway. Another was situated half-way across the bridge adding a fortress-like note to the approach into Moret through its towering gateway (see Plate 42).

In this painting Sisley has positioned himself beside the main bridge looking right towards the mill (destroyed, along with the others, during the Second World War). Clothes were washed in the river, at the right (where it was comparatively shallow; Fig. 34); the flow here, among rocks and reeds, contrasts with the rush of the water over a small weir seen through the walkway along which workmen convey goods. The composition echoes Sisley's earlier paintings of bridges thrusting deep into the picture space (eg Plates 8, 10 and 20). The somewhat inconclusive right side of the painting, lacking in focus or depth, is compensated for by the evocation of the sound of water, suggested through Sisley's complex adjustment of brushstroke and variety of reflections.

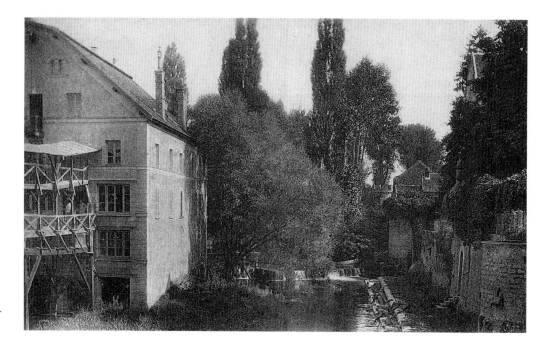

Fig. 34
Provencher's Mill and washerwomen, Moret-sur-Loing, c.1900

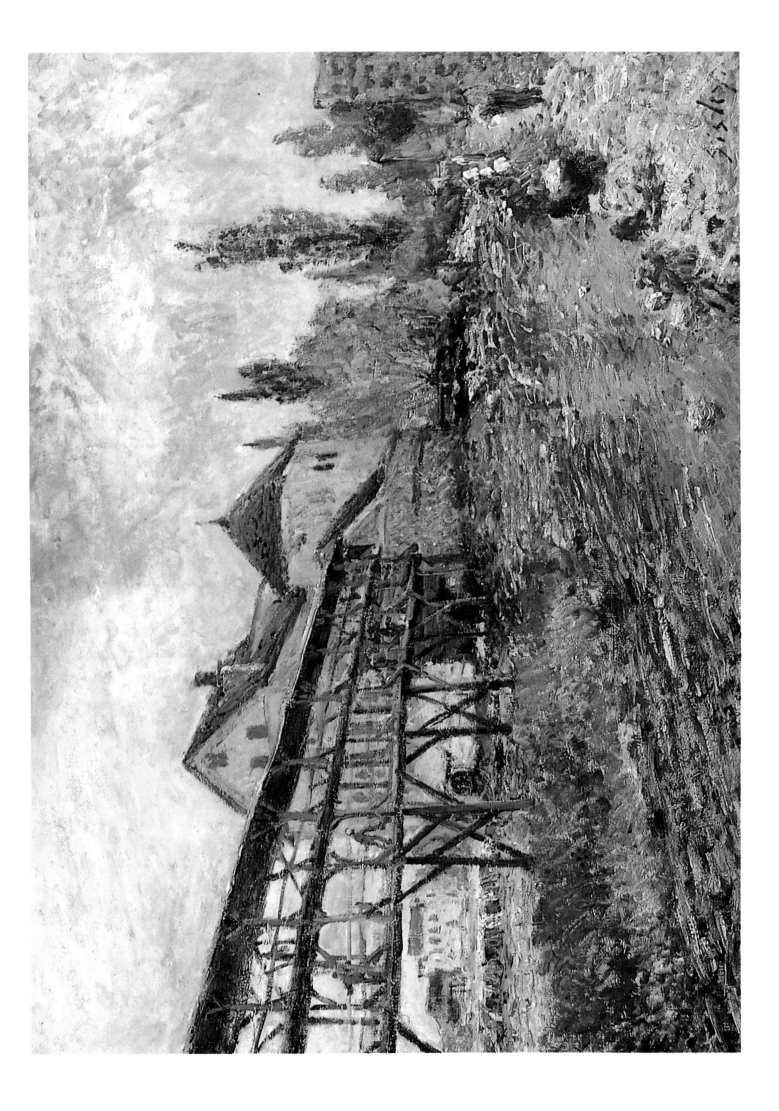

Snow Scene, Moret Station

1888. Pastel, 18 x 21.5 cm. National Gallery of Scotland, Edinburgh

Sisley took to the use of pastel relatively late in his career, probably encouraged by his dealer Durand-Ruel as being a less expensive medium than oil, requiring less time to execute and being easier to sell (which proved to be the case).

His pastels from the late 1880s onwards are entirely of landscapes and the finest group is undoubtedly the series carried out in early 1888 of which the one shown here is a part. It is a winter view from an upper window of his house at Les Sablons. Most of the series include the sidings and goods-yard of Moret's railway station viewed through several bare trees just beyond the artist's garden wall and gate. In this work figures trudge through the snow. Sisley's raised viewpoint and linear delicacy again reveal his rapport with Japanese art – in the downward plunge of the foreground, the diffusions of focus in mid-ground, the expanding horizon, all spatially organised between the crisp staccato verticals of the tree trunks. The window from which he worked afforded a panoramic view and the eight pastels that resulted give a visual sweep of 180 degrees, all unfolding like a fan with the added effects of seasonal change and transitions of mood.

Moret-sur-Loing

1891. Oil on canvas, 65 x 92 cm. Private collection

This summer afternoon view of Moret seen across the Loing, is one of Sisley's largest and most imposing versions of the subject from the 1890s. The tight, dry handling of paint has not prevented him, however, from capturing a breadth of design and considerable decorative aplomb in the overall treatment. The complicated series of planes of the bridge and buildings, solidly rendered, appears to float the town between sky and river. Subtle rhythmic correspondences echo through the painting – cumulus clouds, the arches of the bridge, the rounded trees. A series of verticals, sometimes soft as in the reflections in the water, or hard as in the sunlit buildings, grouped in the left side of the painting, are balanced by the predominant horizontals of the right side, crossed by the rank of tree trunks. Air and light predominate in this quintessential view of the Ile-de-France, still virtually unchanged (Fig. 35). The obvious picturesqueness of the scene left Sisley unabashed (he described Moret as 'chocolate box' in a letter to Monet). For him, it contained all those elements that had entranced him since he had become a painter.

Fig. 35
Moret-sur-Loing,
1991

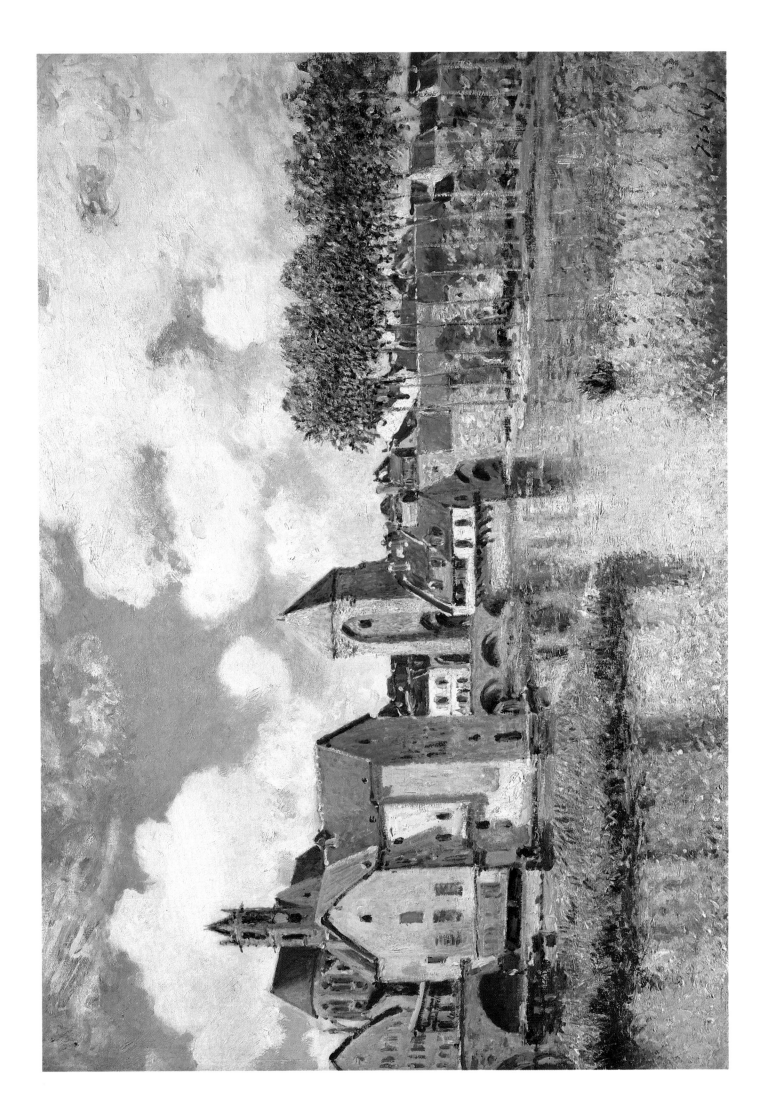

43 The Canal du Loing at Moret

1892. Oil on canvas, 73 x 93 cm. Musée d'Orsay, Paris

As it skirts the edge of Moret and goes south, the Canal du Loing assumes a quieter mood after its busy confluence with the River Loing north of the town. Sisley delighted in its tow-paths on either side, affording him clustered lines of perspective running to a low horizon; towering poplars give those marked vertical divisions that make for strong surface pattern, offsetting the diagonals that take us gently into the distance. Plate 43 is his best known painting of the canal and has all his favourite elements carried out with an inimitable economy of colour – ochres, blues, soft violets, very pale greens in the spring sky above the far hillside. The house across the canal and the barge and figures provide all the necessary darker accents. It is rare among Sisley's later paintings to find a work so simply achieved yet so subtle in all its intervals, like one sustained passage of melody drifting out of earshot.

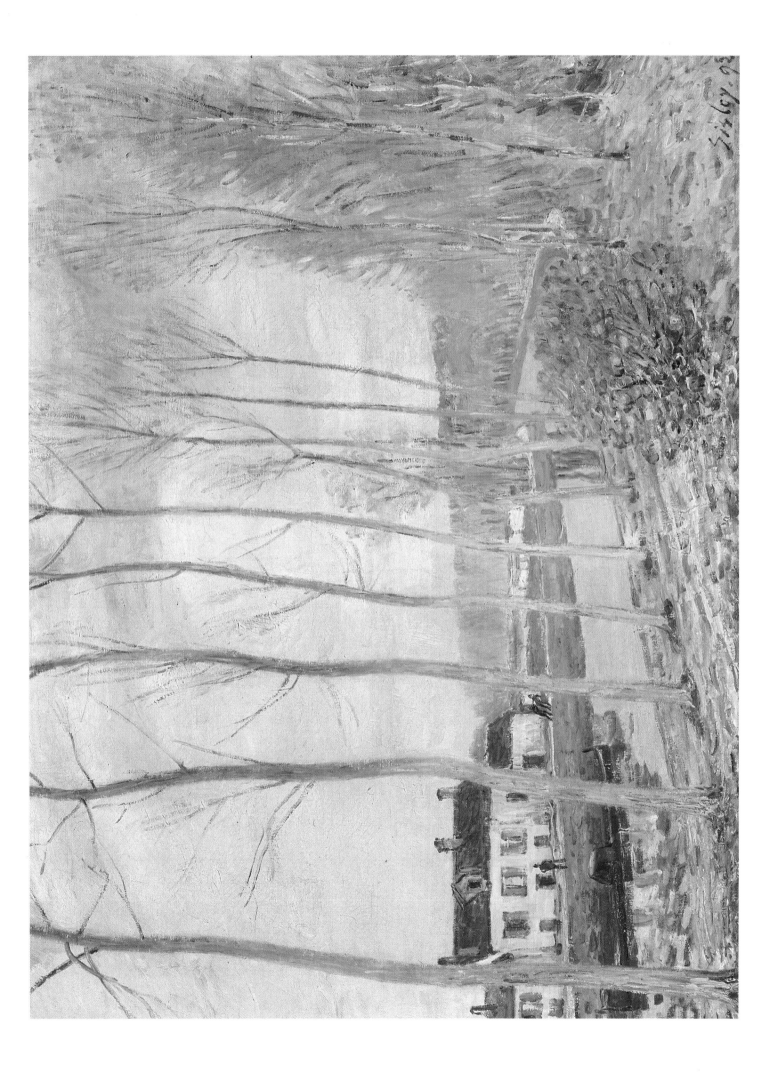

View in Moret (rue des Fosses)

1892. Oil on canvas, 38 x 46 cm. National Museum of Wales, Cardiff

The last decade of Sisley's life was spent in Moret itself in a small house (19 rue Montmartre) close to the church. Save for the extensive group of paintings of the Eglise Notre-Dame (see Plates 45-47) Sisley only occasionally painted views in the town itself. There was a small group of Moret from the bridge (Fig. 36) of c.1888 and a handful of street scenes. Perhaps a growing aloofness on Sisley's part made him reluctant to paint in the streets, with all the social incidents and interruptions such an activity entails.

Here he shows a quiet corner of the rue des Fosses which formed the old walled boundary of Moret. He has positioned himself in the forecourt of the village school (now an open space of grass) looking into the street which led to its western gate, the Porte de Samois.

Fig. 36
Moret-sur-Loing –
Rain
c.1888. Oil on canvas,
54 x 73 cm. Private
collection

The Church at Moret in Morning Sun

1893. Oil on canvas, 80 x 65 cm. Kunstmuseum, Winterthur

There are 14 paintings of the Eglise Notre-Dame at Moret, all viewed from the same angle (south-west) in different weather and in different seasons. They appear to have been completed between summer 1893 and summer the following year. All save one include the façade of the building with its richly decorated Gothic portico; seven are vertical canvases, the others horizontal. Sisley seems to have taken his vantage point from a first-floor window (or possibly the front door) of a corner house in the rue de Grez (a view popular in contemporary postcards; Fig. 37). Begun in situ, it is likely that they were finished in the artist's studio. Small groups were exhibited together in Sisley's lifetime and single ones were acquired by collectors soon after completion. It would appear from this that he did not envisage the series being shown in its entirety.

In the 1870s Sisley's work was notable for its subversive elements – not only the free and improvised handling of paint but also his sometimes reckless composition, unusual viewpoints and an unhierarchical attitude to his subject matter, mixing the picturesque with the banal, the grand with the everyday. In the 1880s something of this complexity was lost in his inexorable concentration on landscape in its purest form. By the early 1890s the artist was aware of an inner need to enlarge the field of his endeavours – '*d'agrandir mon champ d'études*' – as he wrote in 1892 to a friend. The scenes of the church at Moret, of which Plate 45 was probably one of the first, would appear to be the result of his intentions.

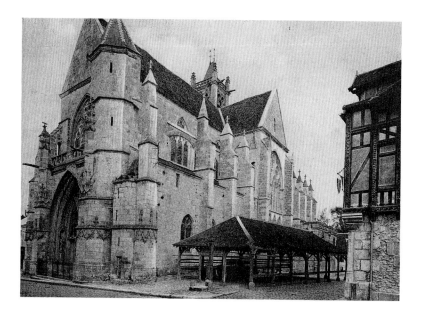

Fig. 37
The Church at Moret,
c.1895

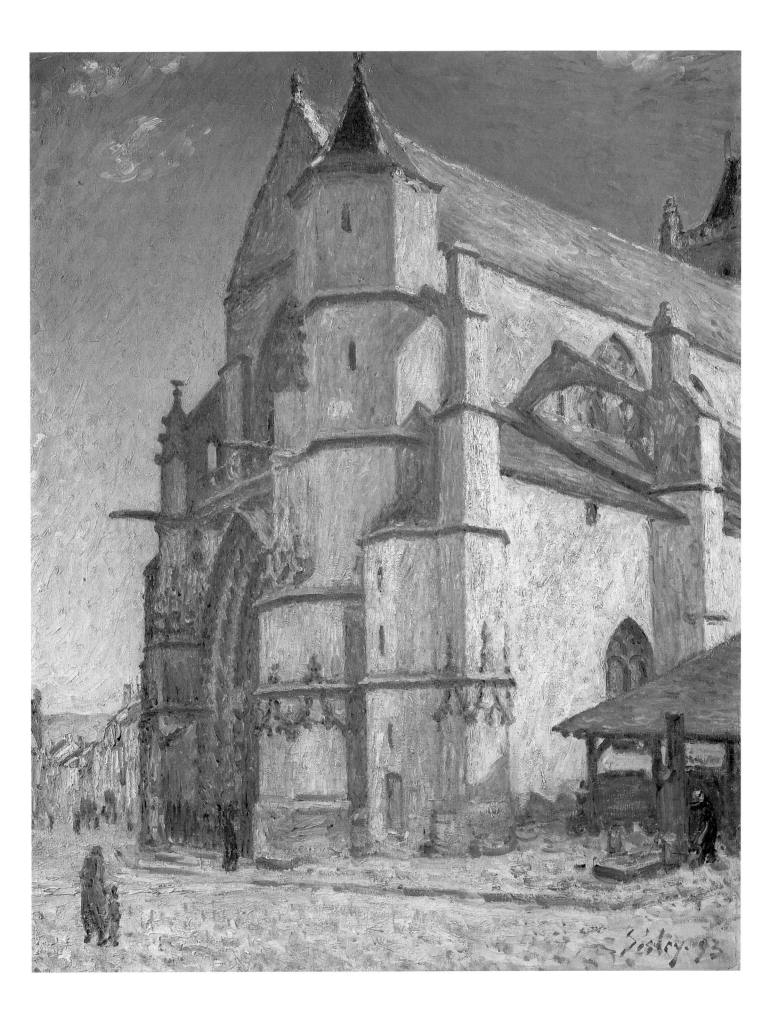

1893. Oil on canvas, 65 x 81 cm. Private collection

Any consideration of Sisley's paintings of the church at Moret raises the question of the influence on Sisley's own conception of Monet's series of Rouen Cathedral. He may not have actually seen Monet's paintings (begun in early 1892 and exhibited in 1895) but he certainly knew of them. He was in Rouen in early 1893 when the painter Albert Lebourg took Sisley through the streets to show him the angle of vision Monet had adopted for the first of his series. Other friends such as the critic Gustave Geffroy would have apprised him of Monet's project. But to hear about it is a different matter from seeing the paintings themselves. Nevertheless, and in spite of Sisley's modest preoccupation with working in series since the early 1870s, the possibility must be entertained that some element of competition with his old friend pointed him in the direction of his own local 'cathedral'.

The paintings have long existed, as it were, in the shadow of Rouen Cathedral, inevitably denigrated in the face of Monet's overwhelming achievement. Certainly, in composition, Sisley was less ambitious. But when a group of the works is seen together, they can appear decidedly impressive through Sisley's refusal to load his canvases with feelings and associations foreign to his temperament.

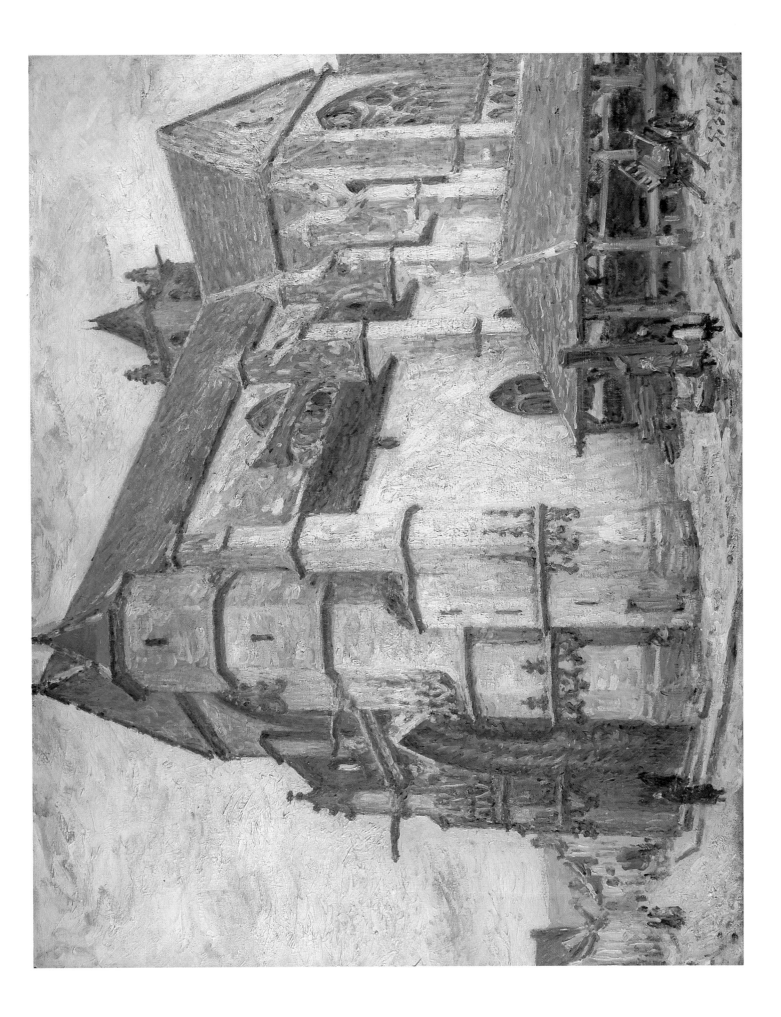

The Church at Moret

1894. Oil on canvas, 100 x 81 cm. Musée du Petit Palais, Paris

Sisley shows the church at Moret in a great variety of times and weather – from a wet December morning to summer sunshine, from dismal winter to late afternoon sun. Incidental detail is kept to a minimum – passers-by change from picture to picture, a cart appears near the pump and covered market to the right (Plate 46); to the left, the rue d'Eglise slips quietly into the distance, never detracting from the church itself. Notre-Dame holds its ground, simple and ornate, bulky and delicate, as it receives the infinitely varied inflections of the light. Now its roof is tangerine against intense blue (Plate 45), now drained of colour on an icy morning (Plate 46). A palpable facture of short strokes, dense or thin, maintains alternations of movement and weight over the whole surface. Sisley's subtle chromaticism is given full play, from the complex intervals of colour on the flying buttresses to the hazy weft of red and violet shadows of the rue d'Eglise (Plate 47).

Each work of the series is pervaded by a characteristic note of withdrawal from the world; Sisley is never distracted or says more than he need. By remaining prosaically steady-eyed, he achieves a visual poetry more akin to the doting tranquillity of earlier Dutch (Fig. 38) and English masters than to Monet's prophetic dissolutions of Rouen Cathedral.

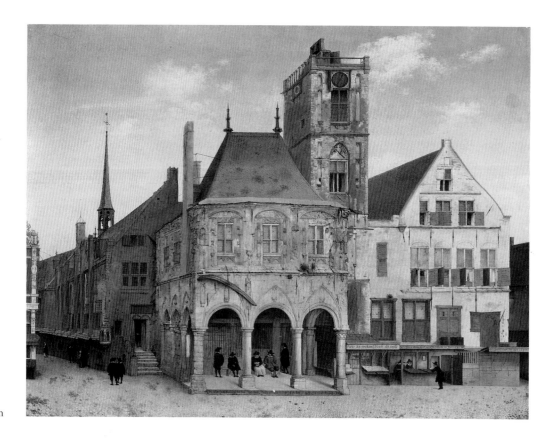

Fig. 38
Pieter Saenredam
Old Town Hall,
Amsterdam, 1657. Oil
on panel, 64.5 x 82.9 cm.
Rijksmuseum, Amsterdam

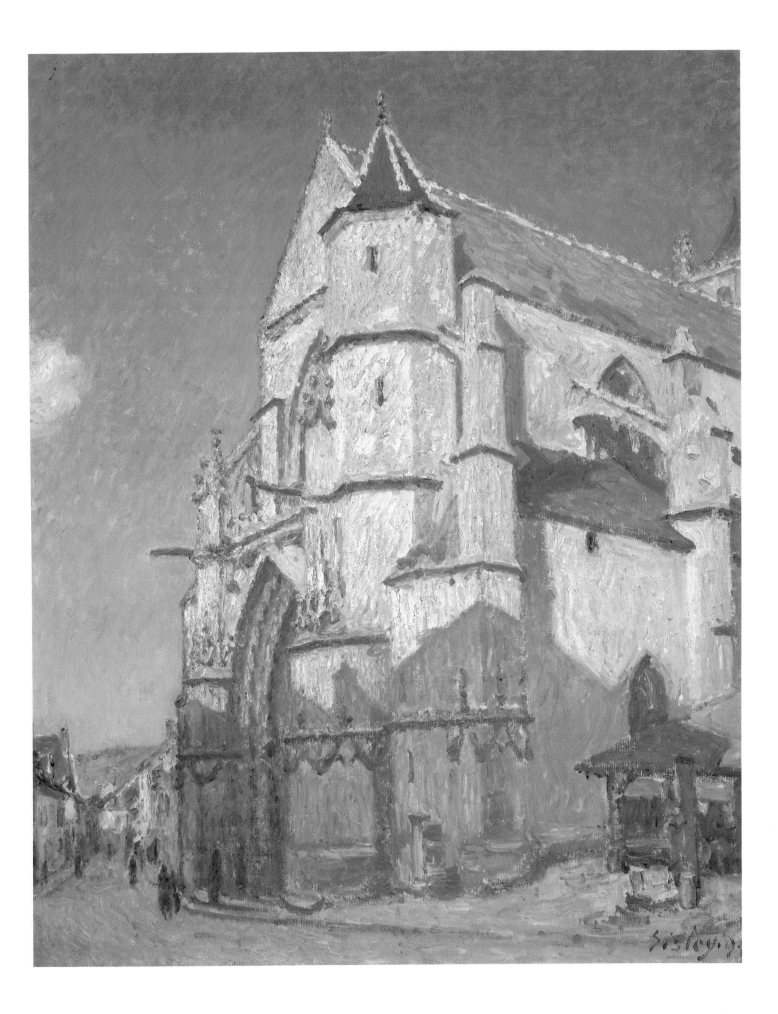

1897. Oil on canvas, 65 x 81 cm. Kunstmuseum, Bern

Sisley spent the summer months of 1897 in South Wales, first at Penarth near Swansea (Figs. 39 & 41) and then at the Osborne Hotel, Langland Bay, further west along the coast. Below the hotel, in a small bay of its own (Rotherslade Bay) is Storr's Rock, much the same today as it was nearly a century ago (Fig. 40). Sisley made five paintings of it, his last substantial group of works. Each takes a different time of day, from morning high tide to evening low tide. Here, the late September sun turns it into a molten and empurpled silhouette.

This strange series of works inevitably has a symbolic resonance. At the same time the paintings suggest the whole direction of Sisley's endeavour, his search for an equilibrium between stability and transience, between material permanence and the flow of light, weather and the seasons. The rock remains hard and tenacious beneath its chameleon changes of outline and colour; breaking against it, the sea sprays into the air, an exemplary image for the close of Sisley's life.

Fig. 39
The Bristol Channel
from Penarth, 1991

Fig. 40
Storr's Rock,
Langland Bay, 1991

Fig. 41
Bristol Channel from
Penarth, Evening
1897. Oil on canvas,
54 x 65 cm. Allen
Memorial Art Gallery,
Oberlin College, Oberlin,
OH

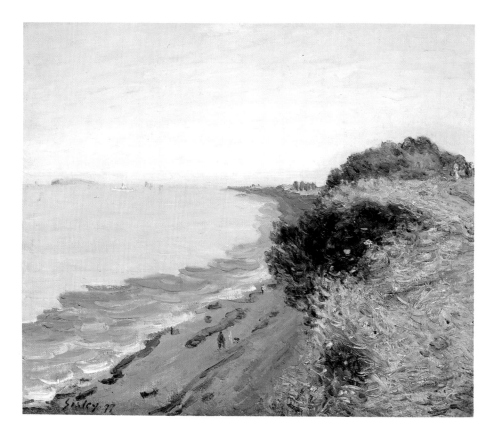

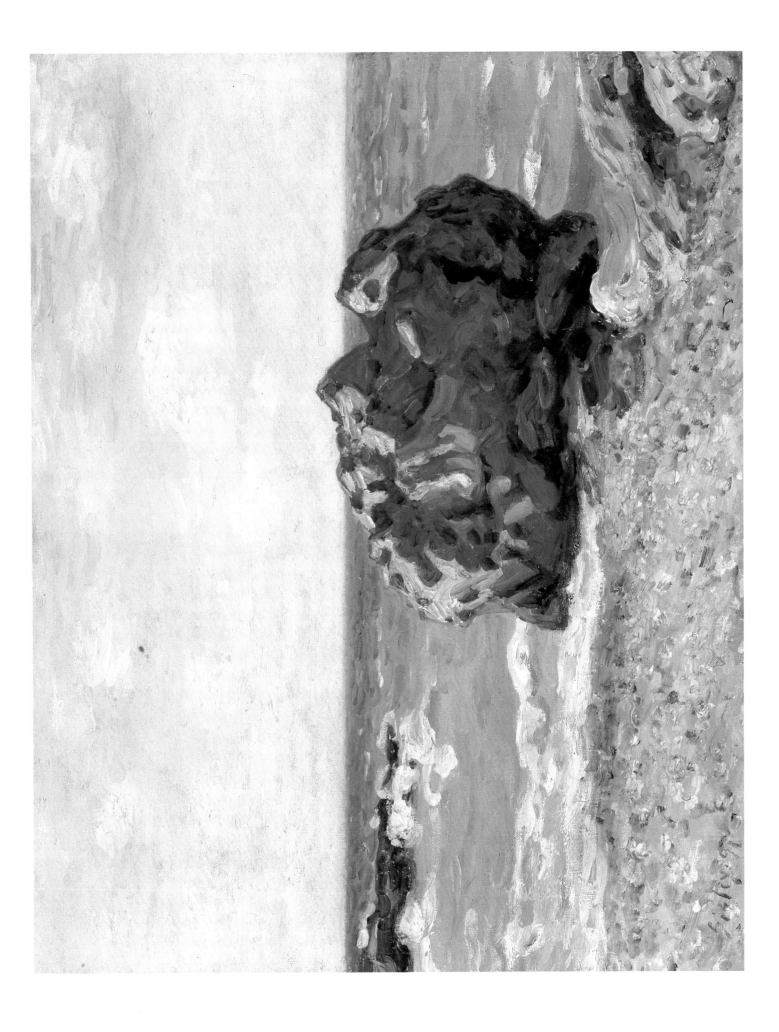

PHAIDON COLOUR LIBRARY
Titles in the series

FRA ANGELICO
Christopher Lloyd

BONNARD
Julian Bell

BRUEGEL
Keith Roberts

CANALETTO
Christopher Baker

CARAVAGGIO
Timothy
Wilson-Smith

CEZANNE
Catherine Dean

CHAGALL
Gill Polonsky

CHARDIN
Gabriel Naughton

CONSTABLE
John Sunderland

CUBISM
Philip Cooper

DALÍ
Christopher Masters

DEGAS
Keith Roberts

DÜRER
Martin Bailey

DUTCH PAINTING
Christopher Brown

ERNST
Ian Turpin

GAINSBOROUGH
Nicola Kalinsky

GAUGUIN
Alan Bowness

GOYA
Enriqueta Harris

HOLBEIN
Helen Langdon

IMPRESSIONISM
Mark Powell-Jones

**ITALIAN
RENAISSANCE
PAINTING**
Sara Elliott

**JAPANESE
COLOUR PRINTS**
J. Hillier

KLEE
Douglas Hall

KLIMT
Catherine Dean

MAGRITTE
Richard Calvocoressi

MANET
John Richardson

MATISSE
Nicholas Watkins

MODIGLIANI
Douglas Hall

MONET
John House

MUNCH
John Boulton Smith

PICASSO
Roland Penrose

PISSARRO
Christopher Lloyd

POP ART
Jamie James

**THE PRE-
RAPHAELITES**
Andrea Rose

REMBRANDT
Michael Kitson

RENOIR
William Gaunt

ROSSETTI
David Rodgers

SCHIELE
Christopher Short

SISLEY
Richard Shone

**SURREALIST
PAINTING**
Simon Wilson

**TOULOUSE-
LAUTREC**
Edward Lucie-Smith

TURNER
William Gaunt

VAN GOGH
Wilhelm Uhde

VERMEER
Martin Bailey

WHISTLER
Frances Spalding